Even in the most miserable living
conditions, Chris found a way to raise
the hearts and spirits of his fellow
Internees.

http://www.friendsoffoundation.org/raphaelhughes

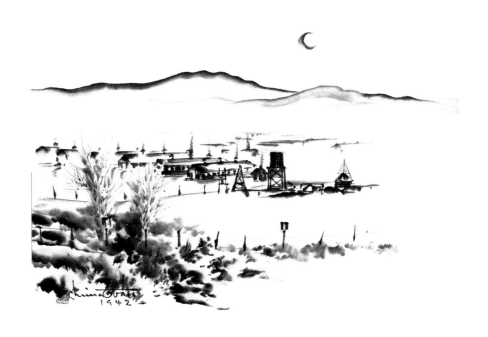

Near Topaz

1942

Sumi on paper, 10¼ x 15¼ in.

CHIURA OBATA'S

Topaz Moon

ART OF THE INTERNMENT

EDITED WITH TEXT BY KIMI KODANI HILL

INTRODUCTION BY TIMOTHY ANGLIN BURGARD

FOREWORD BY RUTH ASAWA

Heyday Books : Berkeley, California

Library of Congress Cataloging-in-Publication Data:
Obata, Chiura.
 Topaz moon: Chiura Obata's art of the internment camps
/ edited with text by Kimi Kodani Hill ; introduction by
Timothy Anglin Burgard ; foreword by Ruth Asawa.
 p. cm.
 Includes bibliographical references.
 ISBN 1-890771-26-0 (pbk.)
 1. Obata, Chiura—Imprisonment. 2. Artists—United
States—Biography. 3. Central Utah Relocation Center—
In art. I. Hill, Kimi Kodani.
N6537.O22 A2 2000
760'.092—dc21
[B] 99-089212

Cover Art: *Silent Moonlight at Tanforan Relocation Center,* 1942
Title Photo: Rose Mandel, ca 1950
Cover and Interior Design: David Bullen Design
Printing and Binding: Publishers Press, Salt Lake City, Utah

Photo Credits: Kim Harrington: 114, 119, 120, 121, 124, 128, 129,
130, 131, 134, 135, 136; Brian Grogan: 113, 125; Sibila
Savage: 85; Iris DeSerio: 147.

Orders, inquiries, and correspondence
should be addressed to:
Heyday Books
P.O. Box 9145
Berkeley, CA 94709
510.549.3564; Fax 510.549.1889
heyday@heydaybooks.com

Printed in the United States of America
10 9 8 7 6 5 4 3 2 1

To my parents,
Eugene and Yuri Kodani

Contents

A Project of the California Civil Liberties
Public Education Program

The editor of this book and the publisher and staff of Heyday Books extend our gratitude to the California Civil Liberties Public Education Program (CCLPEP) for making available the funds to complete *Topaz Moon*. We hope our work will help fulfill the program's goal of increasing awareness about the dangers of racial discrimination, so that injustices like the World War II internment of Japanese Americans will never happen again.

The California Civil Liberties Public Education Program was created through legislation known as the California Civil Liberties Public Education Act, or AB 1915 (Chapter 570 Statutes of 1998). This legislation was introduced in the California State Assembly in 1998 by Assemblymember Mike Honda of San Jose.

In one of the most public and far-reaching of the reparation activities, the CCLPEP provides grants for the development of public educational materials and activities to ensure that the forced removal and incarceration of U.S. citizens and permanent resident aliens of Japanese ancestry will be remembered. CCLPEP is administered by the California State Library under the leadership of State Librarian Dr. Kevin Starr.

With this program, California has taken the initiative in recognizing the need for further education and materials on this important chapter in our nation's history. Besides being home to more Japanese Americans than any other state prior to this tragic incident, California was also the site of two incarceration camps and thirteen temporary detention centers.

CCLPEP is a three-year program (1999–2002). For more information contact Diane M. Matsuda, Program Director, California Civil Liberties Public Education Program, (916) 653-9404, dmatsuda@library.ca.gov.

Acknowledgments

I wish to thank all the countless individuals
who helped in the creation of this book during
the past fifteen years. They contributed in many
ways: with interviews, research assistance, transla-
tion work, enthusiasm, and support. In particular
it was a great honor to interview four remarkable
women: Hisako Hibi, Geraldine Knight Scott,
Ruth Kingman, and my grandmother, Haruko
Obata. I would also like to acknowledge the
Obata friends including Wilder Bentley, Karl Kas-
ten, Beth Blake, Dorothy Skelton, Guyo Tajiri,
Doris Heinz, May Blos, and Shichinosuke Asano,
who early in this project were essential in helping
me understand the lives of my grandparents.

I gratefully acknowledge the following insti-
tutions for providing photographs and materials
from their collections: the Bancroft Library of the
University of California at Berkeley; the Berkeley

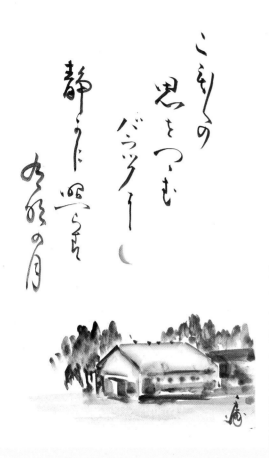

The Moon at Dawn
ca 1942
Sumi and watercolor on paper, 19 x 12½ in.
Collection of Yo Kasai

The barracks envelop
Many thoughts.
Calmly shines
The moon at dawn.

who was the catalyst for me to write this book. For their help in seeing this project to completion I am grateful to Bessie Chin and my sister, Mia Kodani, for their generous assistance, and to Ibuki Lee and Kristine Kim for answering my many questions. A special thanks to Akiko Shibagaki for her translations, to Jane Beckwith for sharing her knowledge of Topaz, and to Gary Otake and Karin Higa for reading the manuscript. I thank my husband, Richard, for his constant support, and Hiro Fujii for her gift of inspiration. I would also like to express my gratitude to Malcolm Margolin, Patricia Wakida, Julianna Fleming, the staff at Heyday Books, and Dave Bullen for their work in publishing this book.

And finally, thank you to my grandfather, who, by never finding time during his prolific career to write this book himself, gave me the rare opportunity to meet and work with so many individuals who derive inspiration from the beauty and transformative power of art.

Kimi Hill, January 2000

Historical Society; the Franklin D. Roosevelt Library; the Fine Arts Museums of San Francisco; the Japanese American National Museum; the Oakland Museum History Department; the National Archives; the Topaz Museum in Delta, Utah; and the Special Collections Library of the University of California at Los Angeles.

I extend my sincere thanks to Mark Johnson

Foreword

I am honored to acknowledge the legacy of two dedicated teachers, Chiura and Haruko Obata. When their lives were devastated by World War II, the Obatas challenged chaos and displacement by immediately mobilizing their artist friends to establish art classes at the Tanforan and Topaz internment camps. The Obatas' reverence for nature and beauty and their strong desire to share their art with students and friends made it possible for them to combine art and life. Their contribution as teachers and artists helped to create something positive out of the internment experience.

At that time in 1942, in the Santa Anita Assembly Center where my family and I were interned, three Disney studio artists also organized art classes using the only materials available: pencils and newsprint. As a sixteen-year-old, I

found this introduction to art magical, and it formed the beginning of my gratifying life as an artist. It has been my fortune that one fulfilling aspect of my career has been promoting art education for children. My work has continued in the tradition of teachers like the Obatas, who clearly demonstrated how art education is essential for the vitality of a community.

The Obatas surely brought a measure of magic to many people through their teaching, their art, and their lives. I hope others will also find the inspiration I have found in their story and their art.

Ruth Asawa, January 2000

The Art of Survival:

Chiura Obata at Tanforan and Topaz

Timothy Anglin Burgard
The Ednah Root Curator of American Art, The Fine Arts Museums of San Francisco

On February 19, 1942, in the aftermath of the Japanese bombing of Pearl Harbor, Hawaii on December 7, 1941, President Franklin D. Roosevelt signed Executive Order 9066, which authorized the exclusion of any person from designated areas of the United States. In practical terms, this order targeted Japanese Americans, although it was also applied to thousands of Americans of Italian and German ancestry who were similarly classified as "enemy aliens," as well as to native Aleutian Islanders. Proponents of the exclusion order claimed that it was prompted by fears of espionage or sabotage, but the origins of Executive Order 9066 may be traced to a long

history of anti-Asian popular prejudice and institutionalized racism. Presented in the guise of nationalism, but usually motivated by a desire to protect the economic prerogatives of earlier immigrants, agitation against the so-called Asian "yellow peril" in the United States began soon after the arrival of Chinese immigrants during California's Gold Rush era. By 1941, there were over 800 federal, state, and local laws discriminating against Asian Americans.

In the months following the signing of Executive Order 9066, the civilian War Relocation Authority transported more than 70,000 American citizens of Japanese ancestry and 40,000 residents of Japanese nationality from the West Coast of the United States to internment camps. Japanese American families were given only a few weeks notice to settle their affairs, and most were compelled to sell their homes, businesses, and personal property at a great loss. Internee Teru Watanabe recalled "We took whatever we could carry. So much we left behind, but the most valuable thing I lost was my freedom."[1]

Among the evacuees was Chiura Obata (1885–1975), who had studied painting in Japan before immigrating to San Francisco in 1903. In 1921 Obata co-founded the East West Art Society, which sought to promote cross-cultural understanding through art. This goal had already found artistic expression through his embrace of the modern *nihonga* (Japanese painting) style, which fused traditional *sumi-e* (Japanese ink and brush painting) aesthetics with the conventions of western naturalism and perspective. As a respected professor of art (1932–42/1945–54) at the University of California, Berkeley, Obata played a pivotal role in introducing the Japanese painting techniques that were to become one of the distinctive characteristics of the California Watercolor School.

As an accomplished artist, Obata was uniquely equipped to give visual form to the complex emotions engendered by the traumatic internment experience. Obata's "Farewell Picture of the Bay Bridge" [page 25] captured his last view of San Francisco as he and other evacuees were transported by bus to the temporary "assembly center" at the Tanforan Race Track in San

Bruno, just south of San Francisco. This aerial view of the Bay Bridge, whose span is visually broken by sheets of falling rain, serves as a metaphor for the internees' severed ties to their Bay Area homes. As Obata later recalled, the dark rainstorm mirrored the melancholy mood of the evacuees as they mourned the past and confronted an uncertain future.

Upon arrival at the Tanforan Race Track, the evacuees, now distinguished only by an official identification number, were searched for contraband and given compulsory medical examinations. New arrivals were housed in inadequate and unsanitary structures, including horse stalls that had been covered with linoleum floor tiles. With a peak population of over 7,000 residents during its seven-month existence, Tanforan was consistently understaffed and overcrowded, and the evacuees had to endure seemingly endless lines for basic necessities.

After an average stay of several months at Tanforan, most Bay Area evacuees were sent to Topaz, Utah, one of ten "relocation centers" administered by the War Relocation Authority and guarded by U.S. Army soldiers. Topaz—ironically named "the Jewel of the Desert"—was located 140 miles south of Salt Lake City in an ancient lake bed on the edge of the Sevier Desert. Situated 4,700 feet above sea level, temperatures ranged from 106 degrees in the summer to 30 degrees below zero in the winter. The annual rainfall measured only eight inches, and there was an ongoing struggle against the alkaline soil dust that permeated the camp.

During its existence from September 1942 until October 1945, Topaz had a peak population of over 8,000 internees. Camp administrators attempted to replicate community services that the internees had been forced to leave behind, including schools, churches, libraries, a post office, and a hospital, but any illusion of normalcy was dispelled by the rudimentary living conditions. Families were housed in rooms that averaged twenty-by-twenty feet, equipped with a ceiling light, a coal stove, and a closet, and were allocated one cot, one mattress, and two blankets per person. Cramped barracks and communal showers, bathrooms, mess halls, and laundries destroyed

any semblance of privacy and undermined traditional familial and communal authority.

Compounding the insult of internment, life at Topaz was characterized by bitter ironies. Camp administrators attempted to promote American democracy by offering classes in "Americanization" and by sponsoring a tightly restricted community council and a censored camp newspaper. In 1943, the U.S. government asked adult internees to sign a controversial loyalty oath. Understandably, native-born Japanese were reluctant to renounce Japan as they were legally barred from becoming U.S. citizens, while many draft-age men resented being asked to defend a democracy that had so blatantly abrogated their own civil liberties.

Despite these trying circumstances—or perhaps in response to them—many relocation centers and internment camps had thriving art, music, and dance programs. The Tanforan Art School, founded and directed by Obata, had sixteen artist/instructors who taught twenty-three subjects to over six hundred students. Soon after several successful public exhibitions of the student

internees' work in Berkeley, Oakland, and Pasadena, Tanforan was closed and Obata organized the Art School at Topaz, the camp to which he and his family were moved. Obata was unexpectedly released from Topaz in April of 1943. The Topaz Art School continued, however, the directorship having passed to his close friend, Matsusaburo (George) Hibi (1886–1947).

Obata created two principal types of artworks while interned at Tanforan and Topaz. The first group of reportorial works consists of in-situ drawings that comprise a visual diary of the internees' daily life. Ostensibly documentary in nature, these dated sketches did not simply record the passage of time, they also reaffirmed an artistic sensibility sustained under physically and psychologically trying circumstances. This sensibility is manifest in Obata's "Entrance to the Obata Dwelling in Topaz" [page 81], which records his family's attempt to create an aesthetically harmonious garden oasis in the midst of their harsh camp environment. The traditional Japanese garden features publicly proclaim the Obata family's pride in their Japanese culture, while the storm-

weathered tree serves as an apt symbol of their perseverance in the face of adversity.

Obata's annotated drawings of the internees complying with the bureaucratic regulations and institutional rituals of the internment camps also bear witness to the individual indignities and outrages that together comprised the larger injustice of the internment experience. "Hatsuki Wakasa, Killed by M.P." [page 94], which records the residents' belief that Wakasa had strayed near the Topaz perimeter fence while walking his dog, is unusual in that it explicitly contradicts statements by camp officials that Wakasa was shot while attempting to escape. A more representative work is "Regulations" [page 119], which conveys the apprehension of a family confronted by a barbed wire fence and a bilingual red warning sign. Like comparable sketches published by Mine Okubo in her well-known internment autobiography, *Citizen 13660,* the impact of Obata's reportorial works is greatly enhanced by their understatement.

Obata's second group of internment works shifts focus from a prosaic recording of human affairs to a poetic evocation of Obata's "Great Nature." Given the perennially crowded conditions at Tanforan and Topaz, it is striking how many of these transcendent works are devoid of any human presence, thus visualizing both the physical isolation of the camps and the psychological alienation of internment. Bathed in the purifying glow of a crescent moon and dawn sky reminiscent of Obata's earlier Yosemite landscapes, "Silent Moonlight at Tanforan Relocation Center" [page 114] nearly succeeds in transforming the ugly camp barracks, stove chimney pipes, and power lines into a peaceful village. Obata's "Sunset, Water Tower" [page 129], depicts a spectacular, arcing array of flame-like clouds that echo the curvature of the earth and that transcend the crude, man-made camp structures below.

In 1945, as World War II neared its end, the internment camps were gradually emptied. Internees were given $25.00, a $3.00 per day meal allowance, and train fare to their original point of evacuation. But many were unable or unwilling to return to their former homes. Those who did return often found that their homes had been vandalized and their personal possessions stolen.

Most former internees suffered from housing and employment discrimination, and some endured beatings, shootings, and fire bombings. This treatment contrasted with the support offered by other Americans who were sympathetic to the internees' plight.

The U.S. government spent over $80 million to implement the internment of Japanese Americans during World War II, although not a single documented case of espionage or sabotage was committed by a member of the Japanese American community. Over 17,000 Japanese Americans enlisted in the U.S. armed forces, many risking their lives to defend democracy while serving in racially segregated units, often while their families were confined in internment camps. The famous 100th Infantry Battalion and 442nd Regimental Combat Team merged and became the most decorated unit in U.S. military history for its size and duration of service. The 442nd also suffered one of the highest casualty rates during the war, and veterans vividly recall being admonished by their interned parents to prove their family's loyalty by never turning back or surrendering.

While the few physical remnants of Topaz largely have been obscured by the harsh desert environment, this traumatic event in the history of Japanese Americans lives on in the memory of the survivors. Until 1988, when the U.S. government issued an official apology and authorized the payment of reparations to 60,000 survivors, Japanese American internment had remained an episode recalled with indignation by the internees, embarrassment by the U.S. government, and only rarely by younger generations of Americans. The 1992 designation of the Manzanar internment camp in California as a National Historic Site, along with the 1999 groundbreaking of a National Japanese American Memorial in Washington, D.C., reveal a new willingness to acknowledge one of the most serious threats in American history to the civil rights and liberties guaranteed by the U.S. Constitution and the Bill of Rights. However, the eloquent artworks produced by Chiura Obata and other interned Japanese Americans have already long served as a powerful and lasting testament to the perseverance of the human spirit when confronted by unreasoning prejudice.

A California Artist

Nature gives us endless rhythm and harmony in any circumstance, not only when we are on a joyous path, but even in the depth of despair we will see true greatness of beauty of strength, beauty of patience, and beauty of sacrifice. Above the borderline of nationality, everybody must feel a deep appreciation toward Mother Earth. . . . If we keep appreciation in the depth of our hearts, not only our senses will develop more energetically . . . but our feeling will become as clear as full moonlight.

CHIURA OBATA, 1933

These words were given in an address by my grandfather, Chiura Obata, at a 1933 meeting of the California School of Fine Art Society of Women Artists in San Francisco. Obata, a renowned Japanese painter, had been invited as a guest lecturer from the art department at the University of California, Berkeley. His audience was living amidst the hardships of the Depression, and he hoped to inspire the young artists to persevere in their studies. Nine years later, Obata spoke similar words of encouragement to a new group of art students. But the circumstances surrounding his speech were far different. Together, he and his audience were facing the upheaval and

humiliation of a forced life within government internment camps.

Chiura Obata, his wife, Haruko, and members of their family—including my mother, Yuri—were all interned in the camps from 1942 to 1943, having committed no wrong except to be of Japanese ancestry. During his internment, Obata not only taught art in the camps, but also produced a volume of artwork of which over 200 paintings and sketches remain. Today, nearly sixty years after his internment, Obata's artwork serves as an enduring testament to the spirit of a people surviving in the face of adversity and expresses his gratitude to the natural beauty that sustained him "as a mother heart comforts lost children."

My clearest memories of my grandfather are of an elderly man who spoke little English during the last years of his life before he died at age ninety. After his death, I researched his life through his words, his art, and his friends, and I can now imagine him in his prime as a university professor. Although only 5-foot-4-inches tall, he commanded respect and impressed his friends with his dignity, confident (if sometimes inaccu-

rate) use of English, and quick sense of humor. By the 1930s he was regarded highly in both the university and art communities as a professor and an artist. In 1938, *Time* magazine reported that "a demonstration of brush painting by a 53-year-old Japanese artist drew an unprecedented number of 1,900 visitors to the old Crocker Art Gallery in Sacramento, Calif., and his atmospheric, formalized landscapes, on view last week, made critics remember him as one of the most accomplished artists in the West."[1]

Born in 1885, Zoroku Obata was raised in the northern city of Sendai, Japan, the only child of an artist father. As a young boy Obata showed a natural inclination for drawing, and at age seven he began training in the art of sumi (ink) brush painting. But Obata also possessed a stubborn and rebellious personality; he was, in his own words, "quite roughneck." By the time he reached age fourteen his father threatened to have him sent to military school. Instead, Obata ran away from home and then, with his father's approval, apprenticed himself under a master painter in Tokyo. Here, he began using his artist name,

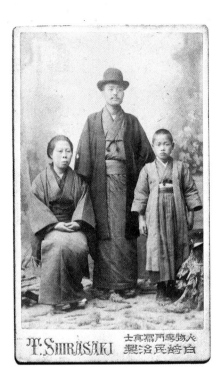

Zoroku Obata with grandmother, Isoko, and father, Rokuichi. ca 1891.

Chiura, in reference to the beautiful "thousand bays" on the coast near Sendai. By age seventeen he had already received painting commissions and recognition for his art. Yet he felt the desire, shared by many of his compatriots, to learn more of the western world. Having convinced his father that "the greater the view, the greater the art; the wider the travel, the broader the knowledge,"[2] he set off for the United States.

Arriving in San Francisco in 1903, the eighteen-year-old Obata worked as a "schoolboy" performing domestic duties while he studied English. He enrolled in the Mark Hopkins Institute of Art, but he was so appalled by his fellow students' lack of self-discipline that he resolved to study independently. Living in San Francisco's Japantown, he found work as an illustrator for local Japanese-language publications. But he also seized every opportunity to study and paint, whether he was exploring the varied California landscape or living in the aftermath of the 1906 earthquake and fire. A refugee camp in a city park was Obata's temporary home after that disaster: "I just learned that however violent is nature, like an earthquake, there is always a way to live if we try our best. I had a nickel when I went to Lafayette Square and after six months when I left I still had a nickel."

Obata met Haruko Kohashi through mutual friends in the Japantown community. Haruko was an educated young woman from Fukuoka, Japan, who had come to San Francisco in 1910 at the age of seventeen. She lived at a boarding house in Japantown owned by her aunt, who wanted Haruko to work at her business. Haruko refused, pursuing her own aspirations to study English

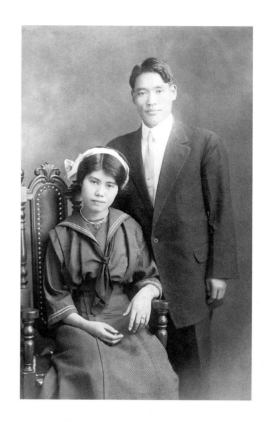

Haruko and Chiura Obata.
San Francisco, ca 1912.

and western sewing. She had planned to return to Japan to teach western dressmaking, but instead, she and Obata married in 1912 with the approval of their families.

Chiura had wooed Haruko with his future plans to travel to Europe and study art. But after he and Haruko had their first son, Kimio, in 1912, they settled in Japantown. They had three other children—Fujiko (1915), Gyo (1924), and Lillian Yuri (1927)—who were also born in San Francisco. Their marriage was a traditional one: Haruko not only assumed responsibility for cooking, homemaking, and child rearing, but she also assisted Obata in his painting. Haruko became an expert at preparing and cleaning the paints and brushes; when Obata was inspired in the middle of the night to create a painting, Haruko would also be awakened.

Haruko became an artist in her own right as one of San Francisco's first teachers of the traditional Japanese art of *ikebana* (flower arrangement), which she had studied since age nine. Her ikebana demonstrations and classes captivated American audiences who were charmed by her

gracious and friendly personality. She said, "Papa [Chiura] used to complain about the other things I did, but he never complained about the time I took to teach ikebana because it was teaching Japanese art to Americans, and he thought that was a good thing." The husband and wife often combined their talents at exhibitions—an Obata painting would serve as a backdrop to Haruko's ikebana arrangement. Among her early accomplishments was a one-room display of her flower

arrangements in the 1915 Panama Pacific Exposition in San Francisco.

Turn-of-the-century California was a hostile environment to Asian immigrants and coping with prejudice was a part of life in San Francisco for the Japanese, including the Obatas. Chiura was hit and spat upon by strangers in the streets, and he once found himself in the middle of a street brawl for which he was arrested, then released, since he was only one against eight. California also had a long history of anti-Asian legislation. United States law forbade Asian immigrants from becoming American citizens, and the 1924 Asian Exclusion Act prohibited any further Japanese immigration. Paradoxically, amidst the prevailing anti-Asian sentiment, the upper classes of San Francisco had a taste for the decorative arts in the fashion of "Japonism."[3] Obata had several large commissions in the 1920s to paint murals and designs for leading department stores such as Gumps and the City of Paris. In 1924 he also designed the sets for the San Francisco Opera's production of *Madame Butterfly.*

Living in Japantown, Obata enjoyed close friendships with other Japanese artists, such as Matsusaburo Hibi, and by 1920 he had also formed significant friendships with American artists including Perham Nahl and Ray Boynton. Obata felt "there was not much communication between the Americans and the Japanese, not even between artists. At least in the world of art there shouldn't be any walls between the poor East and the rich West." These friends, together with thirty-four other Japanese, American, Russian, and Chinese artists, established a unique art association, the East West Art Society. In 1922, the group held their first painting exhibition at the San Francisco Museum of Art.

Obata's empathy and admiration for the California landscape deepened with a 1927 camping trip to Yosemite and the High Sierra with his good friend, Worth Ryder, a U.C. Berkeley art professor. Obata was forty-two years old at the time, and his skill as an artist had fully matured. "This experience," said Obata, "was the greatest harvest for my whole life and future in painting." Not only did the Sierra landscape inspire him visually, but more important, he found in the

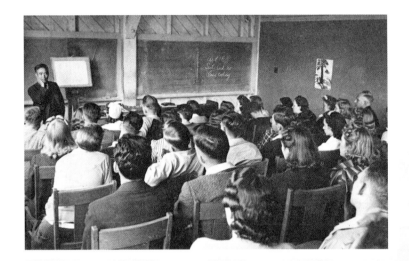

Chiura Obata teaching at Spreckels Hall, UC Berkeley, ca 1935.

mountains a spiritual inspiration. The reverence and gratitude toward the natural world that was inherent in his Japanese training found new meaning when he encountered the majestic beauty of granite peaks and the pure tranquillity of mountain lakes.

In 1928 Obata held his first one-person exhibition for American audiences featuring his images of the California landscape. That same year, the Obata family was obligated to return to Japan after the death of his father. As the only son, it was Obata's duty to continue the family line as an artist and teacher. Obata's younger children, Gyo and Yuri, adjusted to their new life in Sendai, but the eldest son, Kimio, also known as Kim, returned to San Francisco to continue his high school education in his native English. Due

to her poor health, daughter Fujiko was left in the care of Haruko's mother. (She died of an illness in 1945.) At the end of two years, the rest of the family returned to America. Obata had lived nearly all his adult life in California and considered it his home.

When he returned to San Francisco there were numerous exhibitions of his work. His landscapes gave an appreciative public a new, yet highly sophisticated interpretation of California scenery. In 1932 Ryder and Nahl invited Obata to teach a summer class at UC Berkeley. The students responded so enthusiastically to his class that he was hired as a lecturer in the art department. Two years later he was promoted to assistant professor. Although Obata did not have a college degree and was not fluent in English, he

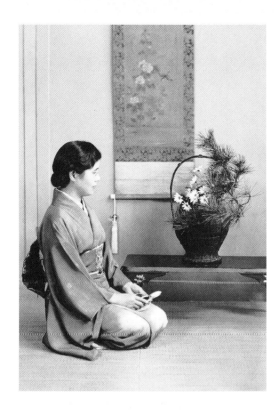

Haruko Obata, ca 1930.

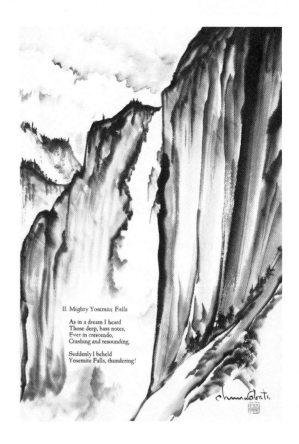

II. Mighty Yosemite Falls

As in a dream I heard
Those deep, bass notes,
Ever in crescendo,
Crashing and resounding.

Suddenly I beheld
Yosemite Falls, thundering!

Mighty Yosemite Falls
The Archetype Press, Berkeley:
Wilder and Ellen Bentley, letterpress, 1937
Sumi on paper, 15½ x 10¼ in.

taught from his own experiences and was un-doubtedly a master of Japanese painting. He taught his students not only the technique of Japanese sumi painting, but also a philosophy of discovering beauty and inspiration in the natural world. He said, "I always teach my students beauty. No one should pass through four years of college without he be given the knowledge of beauty and the eyes with which to see it."[4]

At their Berkeley home the circle of friends surrounding the Obata family expanded from their many *Issei* (first-generation Japanese American) and *Nisei* (second-generation) acquaintances to include European Americans from the university. The Obatas generously opened their home to students and friends, whether for meals or for

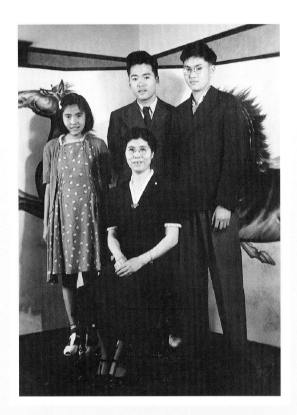

Yuri, Haruko, Kim, and Gyo in front of a screen by Chiura Obata, Berkeley, ca 1938.

extended visits. Obata's teaching position at UC Berkeley provided economic security during the Depression and allowed him to devote his full time to teaching and painting. Haruko organized the household while devoting much of her time to teaching ikebana, and her flower exhibitions included prize-winning displays at the annual California Spring Garden Show.

Their children were also actively involved in the Berkeley community. The eldest son, Kim, studied art and design at UC; worked as art editor for the student newspaper, the *Daily Cal;* and pursued a wide range of college activities from fencing to card stunts during football games. Gyo and Yuri attended the Berkeley public schools. The family spent summer vacations together camping in Yosemite Valley or visiting friends on the Monterey coast, where Obata enjoyed fishing as well as painting.

At home the Obatas lovingly cultivated their Japanese garden to produce floral materials for Haruko's ikebana and subjects for Chiura's paintings. The thriving garden reflected the stability and prosperity of their lives. Yet Obata insisted, "I am not a finished artist, I am studying until I die."[5] He would soon face one of his greatest challenges as an artist and a teacher. The family could not have imagined that in a few years their garden, as well as their thriving lives in Berkeley, would be completely uprooted by the politics of race and war.

Landslide

These paintings are a record of how I felt and described the war as a tidal wave sweeping over all our people in a raging whirl of destructive sentiments.

CHIURA OBATA, 1947

By the late 1930s there were over 300 Japanese American families living in Berkeley and over seventy businesses owned by Japanese Americans. For the Obatas, Berkeley was a safe and convenient place to live, with good educational opportunities for their children. Still, the community tended to socialize within their segregated churches and organizations. Housing restrictions kept most of the Japanese American community contained in one area of the city, and few white-collar jobs were available to Japanese Americans.[1] Even with a master's degree, Kim Obata could not find a job in the design field. So in a collaborative business with his parents, he became man-

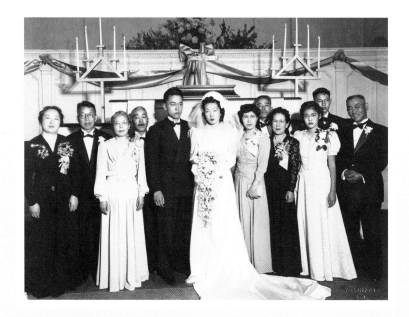

Wedding Portrait of Kim and Masa Obata, First Congregational Church, Berkeley, September 1941.

Left to right: Iku and Dwight Uchida, Hide and Teizo Sato, Kim and Masa Obata, Haruko and Chiura Obata, Okiyo Okagaki, Yuri Obata, Gyo Obata, and Kichitaro Okagaki. Photograph by Hiroshi Yoshizato.

ager of the Obata Studio on Berkeley's Telegraph Avenue in 1939. The storefront was divided into two parts: a shop area for the sale of fine and decorative arts imported from Japan, art supplies, and Obata paintings, and a studio area for classes taught by Chiura and Haruko. After his marriage in September 1941 to Masa Sato, a fellow university graduate, Kim also helped operate a second store in Oakland with his in-laws.

With the rise of Japanese militarism in the late 1930s and the subsequent deterioration of relations between the United States and Japan, Chiura Obata became increasingly concerned about the escalating conflict between his native and adopted countries. Wilder Bentley, a friend who operated a letterpress studio in Berkeley, noticed Obata's change of mood:

Hirose Tansu, the poet, expressed in his poem his need to reconcile himself with his former friends, now his political enemies. Chiura recited the poem to me in Japanese, and later we translated it together. I think this was Chiura's unconscious warning to me to remember these things because he had a foreboding of evils to come . . . this poem became a kind of aesthetic and ethical pact between us when tensions grew, and I could see that Chiura was boiling inside.

Open the rustic bamboo gate at dawn.
All around us lies the frost, white as snow,
Until 'tis thawed by ten thousand summer suns.
'Tis bitter cold this morning,

Thus you and I had better learn to love one
 another.
You'd better fetch some water at the stream,
Whilst I gather kindling wood.[2]

In 1941 Robert Sibley, president of the UC
Berkeley Alumni Association, invited Obata and
other faculty members to a confidential meeting.
It was here that Obata first heard the proposal to
put Japanese Americans into reservations similar
to those of the American Indians. Obata recalled:

*When I went there this young politician talked
about an evacuation. He said, "Evacuation," and
that all the Japanese who lived in California and
other places would be taken somewhere else. I was
really surprised. I thought the Japanese in California
are a people who live by working early in the morn-
ing until late at night to produce the blessing of the
earth. Ninety percent of them are like that. It is im-
possible to suspect these people who are engaged in
Great Nature of being spies. In the first place, you
can evacuate people at a time of natural disaster like
a flood, high tide, or fire, but you shouldn't have an
artificial evacuation. We don't believe in that. And
especially to do something like that against the Jap-
anese is against the will of the founding of America.
I told them I completely disagreed, and we had a big
argument. At first the meeting was supposed to be
just thirty minutes, but we ended up arguing for
two hours.*

Later that year, on the evening of December 6,
Obata dined with Bentley and Karl Kasten, one
of his students. When Kasten asked about the
tense political situation, Obata replied, "It's very
grim. It's serious."[3] The next morning, Sunday,
December 7, Obata left the house early to go
fishing with a companion. Haruko recalled:

*On Pearl Harbor Day I was doing a big laundry.
I took it outdoors to dry, when Kim came running
and said, "Pearl Harbor! The Japanese are bombing
Pearl Harbor. Listen to the radio!"*

*We put on the radio, and everyone was shocked.
This will be terrible. . . . From now on my main
worry was how the Americans will treat us. I was
thinking, I wish Papa would hurry up and come
home. When he came home he too was shocked
at the news. He also wondered how the Americans
would treat the Berkeley Japanese. What they would
do to all the Japanese, we couldn't know.*

After the attack on Pearl Harbor, the Obatas, like all the Issei, had no idea what would happen to them. They learned that the leaders of the Japanese community were being arrested and taken into custody by the FBI. Their friend, Dwight Uchida, a retiree of a Japanese firm, had been arrested on December 7 and was soon sent to a prison camp in Montana.[4] Haruko prepared for the worst:

I thought Papa might be picked up, so I packed pajamas, razor, and any essentials in a small suitcase in case he had to leave suddenly. Some men came and questioned Papa about his activities with various organizations, and after Papa answered everything, they said he did not have to go with them. They warned us that there might be trouble so we should stay quietly at home.

Meanwhile, the Obata Studio store was the target of gunfire, which left a bullet hole in the window.

After the bombing of Pearl Harbor, the press printed rumors and hostile editorials accusing the Japanese community of collaborating with the Japanese military. Inflammatory accusations of sabotage, conspiracy, and treachery went unabated in the climate of war hysteria. However, the Obatas' many American friends showed their continued support in words and gestures. One of Obata's former students, Beth Blake, was living in Honolulu with her husband, a colonel in army intelligence. She had witnessed the terror on Pearl Harbor Day and had not seen her husband for four days after the bombing. In March, she expressed her empathy with Obata in this letter:

Now that man-made lights are out [the moon is] very bright and very sad, like your painting of the Madonna. I feel I must write you a few of [my thoughts]—very few—for writing them is not necessary when there is the moon. For that is one thing that wars and even great distances cannot take away from those who will but gaze upon her.

I have been recalling the many things you have taught me—and how little did I thus realize that they were to help me in the strange places and duties I have had to experience of late. Long nights/twelve hour hospital duty during December, with eight hours straight through the next day. How? I could hear Obata say, "When the mind keeps the good

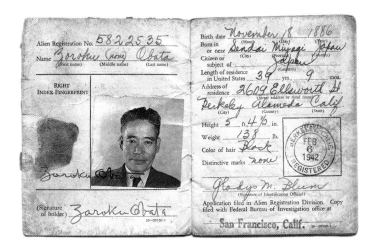

Alien Registration Card for Zoroku [Chiura] Obata. In 1942 enemy aliens were required to have certificates of indentification.

vision straight ahead and the work is good there will yet be strength for the work to be accomplished." And it is now the time for work for everyone— and all work together here.[5]

One of the few organizations dedicated to remedying the plight of the Japanese Americans was the Pacific Coast Committee on American Principles and Fair Play. Based in Berkeley, its members included Galen Fisher, a former missionary in Japan; educators from the University of California, including President Robert Gordon Sproul (who served as the committee's honorary chairman) and Vice President Monroe Deutsch; and Berkeley Mayor Frank Gaines. When the exclusion order became inevitable, the committee accepted the fact of evacuation, but fought to influence policy and public opinion to ensure the

evacuees' eventual return to the West Coast. Executive secretary Ruth Kingman later explained how the Fair Play Committee countered the public and political forces against the Japanese Americans: "This was our contribution to the war effort. Because, after all, in our own way, we were fighting for democracy, for American principles. And this would maintain the high American principles that we weren't going to lose sight of and become racist."[6]

On February 19, President Roosevelt signed Executive Order 9066 authorizing the exclusion of Japanese Americans from the West Coast as a "military necessity." In March, an 8:00 p.m. curfew and a five-mile travel limit was imposed upon the Japanese Americans. As required, Chiura and Haruko were registered and fingerprinted as

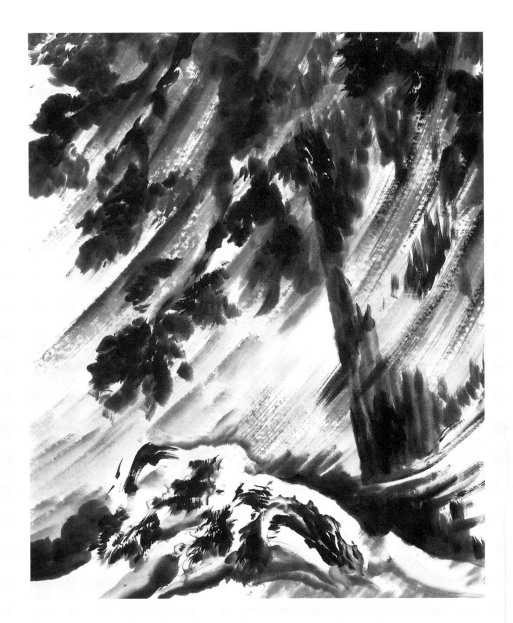

Struggle
1941
Sumi on paper, 24½ x 30½ in.

In war there is the struggle of battle, but more important to humanity, there is also the struggle against the hatreds of war. In struggle there is beauty; out of struggle comes beauty; when man seeks to rise above himself, he creates beauty. Chiura Obata sees it as a great red-wood tree rearing up magnificently with summer's heat, slashed by lightening, buffeted by wind, bur-dened by winter's blanket of snow. Rocked by the earth's shakings and slides, resisting a host of enemies, the old tree slowly reaches skyward to eternal beauty.

EXHIBITION TEXT, 1946

enemy aliens. By mid-March the mass removal of Japanese Americans in California had begun. The Obatas knew their evacuation from Berkeley was imminent.

The Obata household began preparations for departure. The burden of packing and closing the house and the store was left largely to Haruko and the children. Chiura continued his schedule of lecturing and painting. Haruko recalled, "Just at that time Papa started a big painting, and he never stopped. He was painting a scene of a tree with a storm swirling around it. I was mad at Papa; he wouldn't help me at all. I had to do by myself, everything."

As the school semester drew to a close in April, Obata gave his annual painting demonstration to the youngsters at the 4-H All-Star Conference. He focused his lecture on the appreciation of the nature of California. Meanwhile, family friends attempted to find a home for the Obatas outside the exclusion zone. Deutsch, who remembered the anti-German American racism during World War I, tried unsuccessfully to relocate the Obatas to Yosemite National Park

(which, until the end of March, was outside the exclusion zone). But ultimately, Obata felt he should stay with the Japanese community. "I decided the best thing for me was to help and support my people in this trying time," he said.

On April 19, a faculty art exhibition opened at the UC Art Gallery. Obata submitted his recent painting titled, "Struggle," depicting a giant sequoia tree in the midst of a snowstorm. Two days later, on April 21, to the headlines, "Japs Given Evacuation Orders Here," the Western Defense Command issued a ten-day notice ordering the evacuation of the 1,300 Berkeley residents of Japanese ancestry.

The Obata Studio was permanently closed, the merchandise sold at a loss. The family turned to sympathetic friends to help store their more valuable possessions. Haruko's ikebana vases, the piano, sewing machine, furniture, books, a radio, and a trunk of kimonos were stored at the homes of students and friends. The new refrigerator and stove were lent to Kim's newlywed friends. But most critical was the safekeeping of Obata's prized paintings. The collection covered the

breadth of his painting career, including screens, scrolls, prints, and framed paintings of all sizes. President Sproul and his wife rescued the paintings, which were safely stored in their official residence on the UC Berkeley campus for the duration of the war.

The week before their departure, as the final packing and preparations were made, Obata finished his grade reports and arranged for the disposal of the remainder of his paintings. Many had already been sold inexpensively during the studio sale. On April 23, Obata conducted a painting demonstration and sold 120 of his paintings. The proceeds of the sale, which brought in $450, were used to establish a scholarship fund administered by a university committee. As announced in the *Berkeley Daily Gazette,* "It will be for the student, regardless of race or creed, who this committee decides has suffered the most from this war."[7]

Amid the chaos of the last weeks before the evacuation, Gyo Obata adamantly refused to go into the camps. Obata recalled, "Gyo was a straight-A student in the architectural school of the University of California. One day I came home, and he was lying on his bed staring at the ceiling. He told me that he would not go to the evacuation camp because it was a constitutionally wrong thing, and he would not obey."[8]

Most East Coast schools had stopped accepting Nisei because military restrictions deemed them dangerous, but Gyo was determined to relocate to the Midwest in order to continue his college education. He had the full support of his father, who saw no purpose in Gyo going into the camps. The UC art department chair, Oliver Washburn, contacted his friend George Throop, the chancellor at Washington University in St. Louis. Gyo was accepted into the school's architecture program, but did not have Army clearance to relocate. Gyo explained, "By that time Japanese Americans had to get special permission to go from Berkeley to San Francisco. I got permission, went to San Francisco where the Army officer in charge said, 'Okay, Sonny, just do like everyone else, Uncle Sammy's gonna take care of you. Just forget about school.' I came back pretty discouraged."[9] But Obata contacted his friend and former student, Geraldine Scott. Her friend, an at-

torney, was working as judge advocate in the office of General DeWitt, the commanding general of the evacuation program. Recalled Scott:

> [The attorney] called me back and said, "I have it scheduled. You get Gyo over here with all his papers at two o'clock." We did, and they reheard the case and granted Gyo permission. By then it was crucial to get Gyo out of town by midnight because they were going to evacuate the next day. The banks were already closed—Mr. Obata and I had to borrow money from everyone [so] we could to get enough to buy a ticket. I took Gyo to the train because of the curfew. I remember he seemed so young to have to go under these circumstances, where he may not have any friends, to just work. He did make friends, of course, and fortunately the hysteria there was not as bad.[10]

As for the rest of the Obata family, by the next day, all the last details for their departure had been attended to as best they could under the circumstances. Haruko recalled:

> We cleaned up the house; our suitcases were packed and ready to go. I was wearing my everyday suit. I had packed blouses, nightgowns, and underwear. Papa's bag had the same. They said don't bring anything, just one suitcase. I had to pack everything we needed in one suitcase—it was awful. We left our other clothes with a friend, Mrs. Hiller. I also brought blankets, sheets, and two pillows. In the excitement of leaving I forgot my best suit hanging in the closet. I still regret that I forgot that suit.

After they left, friends returned to the vacated house. The Obatas had asked them to retrieve the last cultivated flowers and cherished plants from their garden. Professor John Haley replanted Obata's Japanese pine in the garden in front of his studio, where the tree has survived even to this day.

Tanforan

In any circumstance, anywhere and anytime, take up your brush and express what you face and what you think without wasting your time and energy complaining and crying out. I hold that statement as my aim, and as I have told my friends and students, the aim of artists.

CHIURA OBATA, 1946

Obata's evacuation paintings began on April 25, 1942, the day he went to the designated departure center at the First Congregational Church to observe the registration procedures. Japanese Americans were not allowed to have cameras, but Obata wished to depict and record the evacuation. He made his initial sketches on notepads using pencil, pen, or brush and ink. These sketches later served as studies for larger paintings.

Ruth Kingman and the church pastor, Dr. Vere Loper, had convinced the church trustees to humanize the evacuation process by offering to locate the temporary Civil Control Center at the church rather than at a firehouse. Each day

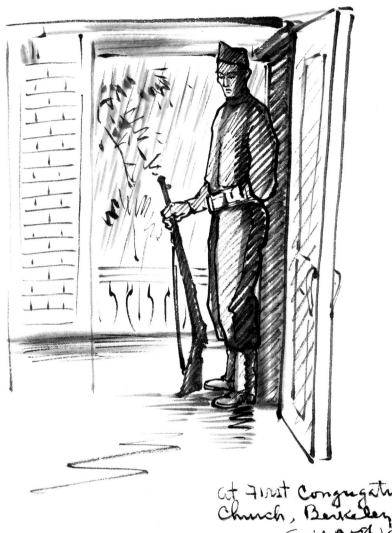

at First Congregational
Church, Berkeley
April 25th 1942
Chiura Obata

Soldier at the Door
At First Congregational Church, Berkeley
April 25, 1942
Sumi on paper, 15¾ x 11 in.

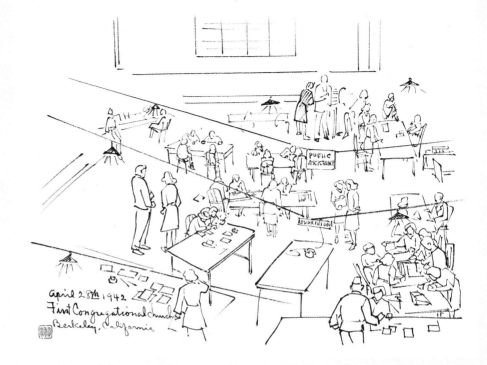

First Congregational Church
Berkeley, California
April 28, 1942
Sumi on paper, 11 x 15¾ in.

[Kim Obata registered as head of
household for both his parents
and his Sato in-laws.]

different Berkeley church groups acted as hosts, serving refreshments and helping to locate homes for pets and storage space for people's belongings.

Monroe Deutsch wrote the following letter to the church on April 28:

Allow me to express my own appreciation for the attitude which you and your church have taken with reference to the Japanese and the American Japanese who are being evacuated. Your action has been one that is proper and will impress these people with the fact that the ideals which we profess we try to put into practice. If any criticize you for it, my only thought would be that they are not truly Americans or Christians.

People fail to recall that these people who are being evacuated have had no charges against them individually; they are not guilty of misconduct. They are being removed because of fear, which is gripping the hearts of some people. Personally, I feel that our country will someday feel ashamed of its conduct in this entire matter. In the meantime, however, it is good to know of actions such as you and members of your church have taken.[1]

Most of the Japanese Americans were evacu-

Evacuation from the First Congregational
Church, Berkeley, April 30, 1942.

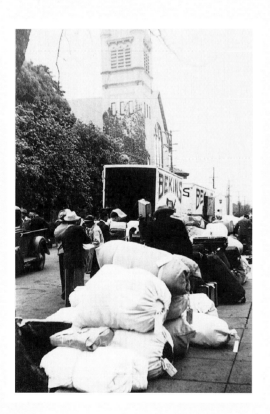

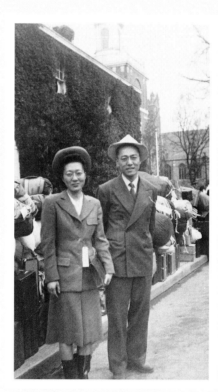

Kim and Masa Obata,
April 30, 1942.
Photograph by Eleanor Breed.
Courtesy of the Berkeley
Historical Society

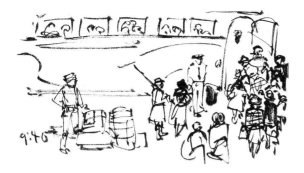

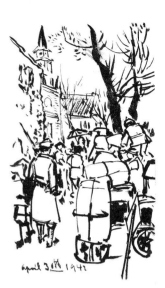

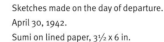

Sketches made on the day of departure.
April 30, 1942.
Sumi on lined paper, 3½ x 6 in.

ated from Berkeley on two days, April 30 and May 1. The Obata family left with the first contingent in the midst of a rainstorm. Haruko said, "We all had tags with our family number. The soldiers were polite to Papa because his papers said he was a university professor. They were respectful and felt badly for us, and one said he was sorry in a low voice."

Eleanor Breed, secretary to the First Congregational Church, had met the Obata family at Kim's wedding. She kept a detailed church diary of the evacuation:

Today I took snapshots of Kim and his bride before the church where they were married, this time with a background of miscellaneous luggage and with identification tags in their lapels. They have been good sports about accepting their setbacks. Their Oakland shop closed promptly after December 7—it had been a wedding gift—and they have been working day and night to clear up the Berkeley Obata Studio where their parents have been for so long. Professor Obata, the father, is taking the evacuation well. He has a small notebook in which he is sketching the process—a silhouette of a soldier at the door, a pic-

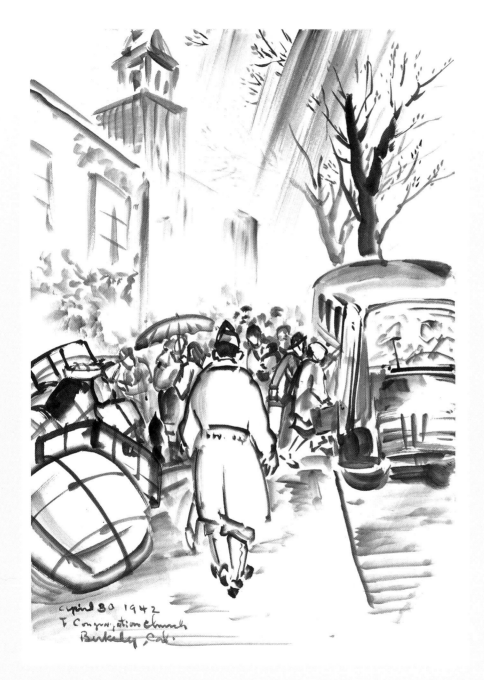

Departure from Berkeley
First Congregational Church, Berkeley
April 30, 1942
Sumi on paper, 20¾ x 14½ in.

*Under the spring rain, our fateful
journey began from Berkeley, California.
Our destiny after "Pearl Harbor" was to
be determined by a Higher Power—
who could foretell our fate?*
CHIURA OBATA, 1942

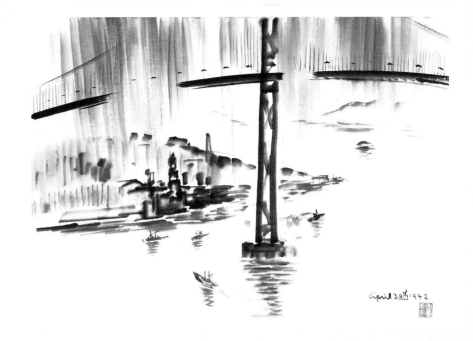

Farewell Picture of the Bay Bridge
April 30, 1942
Sumi on paper, 15 x 20½ in.
The Fine Arts Museums of San Francisco,
Gift of the Obata family, 1996.10.

*While buses carried us across the great
San Francisco Bay Bridge, we caught a
glimpse of the San Francisco skyline
silhouetted in the rain. We felt a tug in
our hearts as we bid farewell to the
familiar surroundings to which we
had become so attached.*
CHIURA OBATA, 1942

*ture of the evacuees getting on the buses with the
church tower high above. Mr. Sato, father of the
bride, is a deacon in the Japanese Congregational
church. He sent a dwarf maple tree from his garden
to Mayor Gaines with a letter asking him to accept
it "in appreciation of the privilege of having lived in
Berkeley and of the protection my family and myself
have enjoyed," and he gave a dwarf pine to Dr.
Loper.[2]*

Art students Dorothy Skelton and Lucille Per-
ryman, nicknamed respectively "Grandma" and
"Snooks" by Obata, came to the church—located
a block from the campus—to bid farewell to their
professor. Skelton recalled:

*Snooks, Bob [Winston], and I were the only stu-
dents we knew who came to say good-bye at this
awful departure. Chiura Obata was so busy help-
ing others retain their composure that he showed no
grief. After the bus left, Snooks and I walked back to
campus, and we could not talk. It was the only time
in my life that tears came down my cheeks while in
public. I shall never forget that day. It was so unfair,
unkind, and unnecessary.[3]*

Kingman remained at the First Congregational
Church until the evacuation was over. "I remem-
ber the last person to leave Berkeley, on the last
bus, the last person to get on," she said. "It was a
man, a middle-aged man, a businessman, who

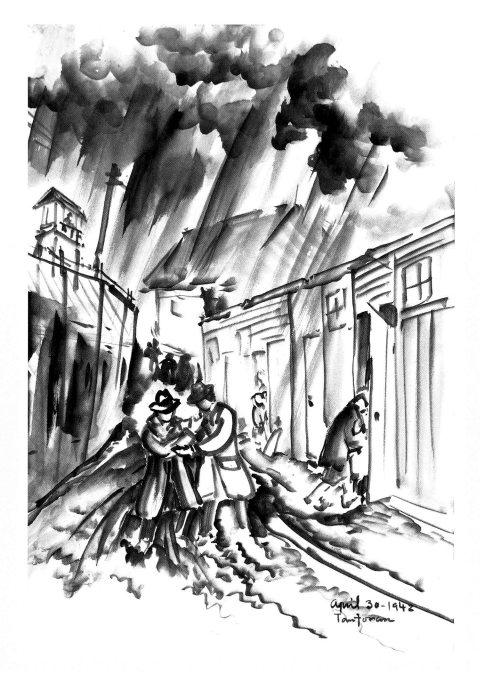

Finding New Dwellings, Tanforan
April 30, 1942
Sumi on paper, 20¾ x 14½ in.

An old blind man struggling in the rain.
CHIURA OBATA, 1946

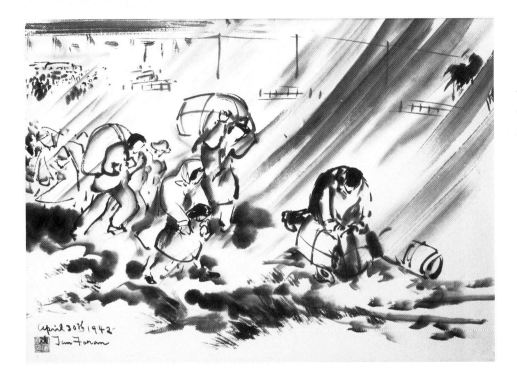

Tanforan
April 30, 1942
Sumi on paper, 15½ x 21 in.
The Oakland Museum of California

carried his crippled mother over his shoulders—
like a baby—just carried her on to the bus leav-
ing for Tanforan. And that was the last person of
Japanese ancestry to leave Berkeley."[4]

Their appointed temporary detention camp
was the Tanforan Assembly Center in San Bruno,
located south of San Francisco, just twenty miles
from Berkeley. Tanforan had been hastily and
crudely transformed from a racetrack into a
temporary residence for 8,000 people. It was
administered by the Wartime Civil Control Ad-
ministration, a division of the Army. Here, the
internees learned a new vocabulary that included
barracks, latrines, and mess halls. On the day of
the Obata family's arrival, the inclement weather
exacerbated an already intolerable situation.
Haruko remembered:

When we arrived at Tanforan it was raining; it was
so sad and depressing. They gave us a horse stable
the size of our dining room with a divided door
where the horse put his head out—that was our
sleeping quarters. There were two beds made of
wood, bunk beds, and another bed on the opposite
wall. . . . There was nothing else, nothing. That one

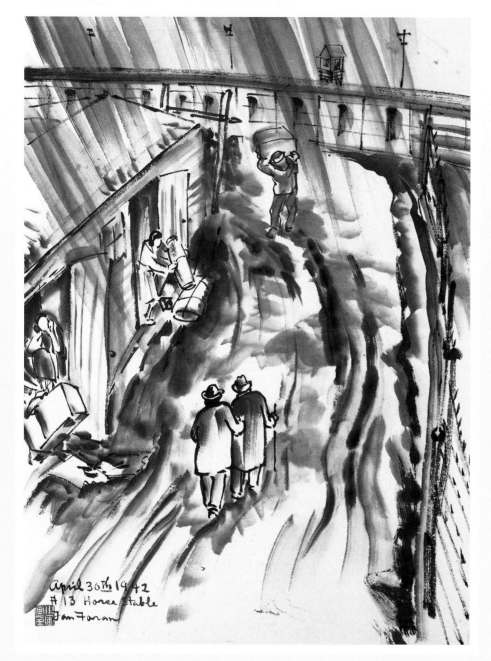

#13 Horse Stable, Tanforan
April 30, 1942
1942
Sumi on paper, 21 x 15¼ in.
The Oakland Museum of California

We waded in rain, through slush and mud up to our knees, only to stumble into empty horse stalls. Many an involuntary sob escaped our lips as we began our life at Tanforan.
CHIURA OBATA, 1942

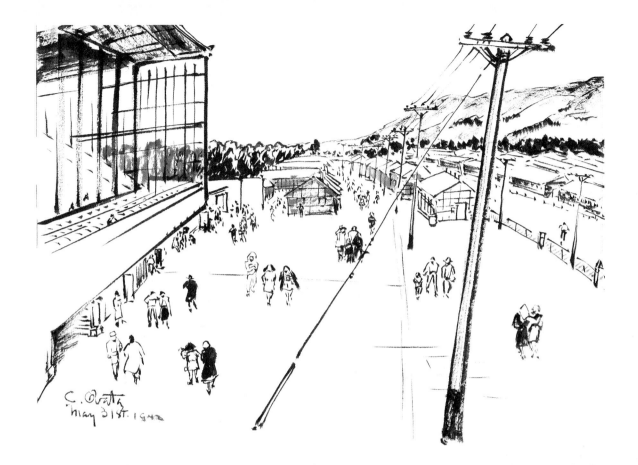

Street Scene from the Grandstand Looking at the Barracks
May 31, 1942
Sumi on paper, 9 x 12 in.

time I cried so much. That was the only time I cried; it was awful.

After five days the Obata family was moved from the horse stables to barrack quarters. For the first ten days at Tanforan they ate little more than lima beans, boiled potatoes, canned food, and bread. The prescribed food allotment for the internees was fifty cents per person per day, but the assembly centers averaged only thirty-nine cents a day.[5] In a letter to one of his former students, Obata described the conditions at the camp:

When we arrived here, it was raining, and we were assigned to three horse stables for the seven of us.

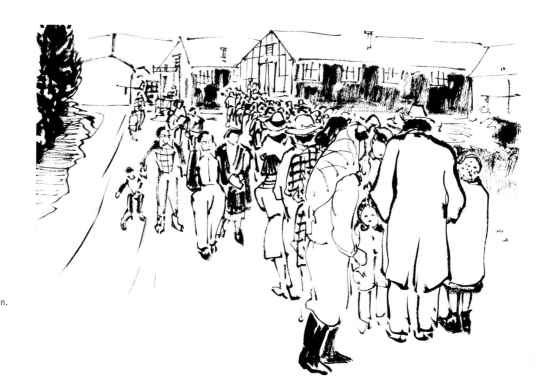

Mess Hall Line
Tanforan, California
May 1942
Sumi on paper, 8¾ x 12 in.

It was with the rain and storm the road in front of our apartments was so thick with mud that the express truck got stuck right in front of our doors. Three cars came to pull the truck out and all of them got stuck in the mud again. I got my heavy rubber boots and helped clear the road. The mud here is rather un-usual—sort of sticky so that when shoes get stuck into it, the foot comes out and the poor shoes remain behind. We stayed in the tenement district for five days and were moved to a barrack, which is our pres-ent living quarter. The room is 20' x 20' and we are all solidly packed into this single room—Kim and

Masa, Mr. and Mrs. Sato, Mrs. Obata, Yuri, and I. I have very little room in which to paint, but I have painted about sixteen paintings of herb flowers, which a friend from Berkeley brought over to me a few days ago. Also, I have made sketches of camp life.

Food during the first week was terrible but has definitely improved, and we are all glad about it.

Horse stables, muddy roads, food, etc., while they are important to the average people—still it doesn't make any difference to me. I have found so many new interesting things here in camp. This is a very good place to study human figures—people of all

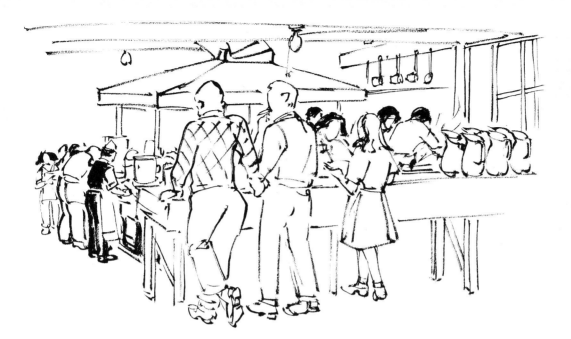

Kitchen
1942
Sumi on paper,
9 x 12 in.

Bachelor's Quarters
1942
Sumi on paper, 11 x 15½ in.

[The racetrack grandstand was
used as a dormitory to house
400 bachelors.]

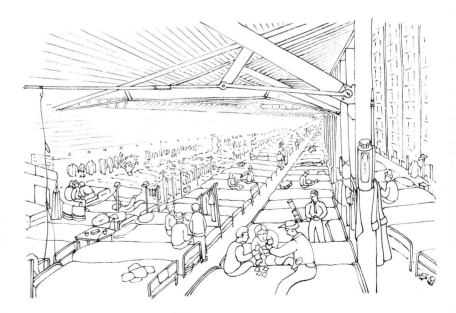

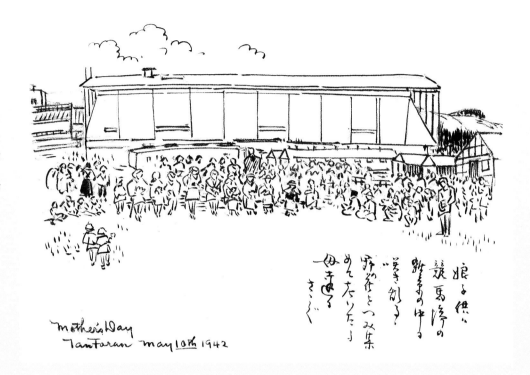

First Camp Celebration
Mother's Day, Tanforan
May 10, 1942
Sumi on paper, 8¾ x 12 in.

The young girls gather wild flowers blooming in the grassy field of the racetrack and present them to their mothers.

娘ら供に
競馬場の
新芽の中の
咲き初むる
野の径をつみ集
めて去りし
母の日に
さく

*Mother's Day
Tanforan may 10th 1942*

ages, of all professions, and backgrounds that I find it most interesting to observe.

When you come [to visit] you can bring fresh vegetables if you can and something good to eat— not only for my stomach but for all my friends too.[6]

Haruko recalled the family's gradual resignation and adjustment to their new way of life:

We were assigned to three horse stalls. At night Yuri was making noise. I asked, "What are you doing?" She was picking out the horse hay in the walls. It still smelled like horse. A horse doesn't need anything, just a rope, and the rest of the time he walks around the stall and puts his head out the door. For our use the government put in the beds. Everyone spent the days outside the stable bringing something to sit on. No windows in the stables and just sitting on the bed wasn't any fun. We wore sweaters and coats all day long. When we had colds we took a lot of aspirin. It was so sad.

[After five days] we moved to a barracks room— all seven of us in one room. Later Kim and Masa moved out, but Masa's parents stayed with us. I disliked living with Masa's father, but we had to live together.

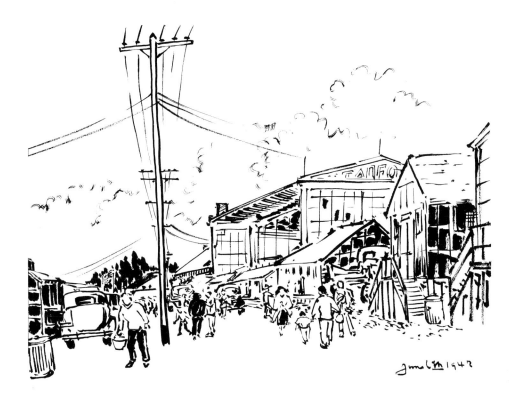

Typical Street Scene at Tanforan Assembly Center
June 6, 1942
Sumi on paper, 9 x 12 in.

We had been told mattresses would be provided, but when we arrived, we found out we had to fill big bags with straw for stuffing. A cloth was put over the stuffed bag. That was supposed to be a mattress.

The only toilets were quite a distance away, and when you had to go at night, it was bad. We would stay up until 11 p.m. and walk the long distance and then get up early in the morning. The shower stalls were open except for a small curtain. The water wouldn't heat fast enough, but we felt dirty unless we took a shower. We washed our clothes in the

It is difficult for me to express how deeply we appreciate the many kind and thoughtful things you have done for us prior to our evacuation. We have [been] so comforted to know how loyally our friends in Berkeley have stood by us at the time when all the world seemed turned against us, and we were uncertain of what the future held in store for us. We hope . . . that all these troubles will soon be settled and we may again resume our normal lives and be with our friends.
HARUKO OBATA, LETTER TO MRS. BELLQUIST, MAY 1942

Barrack 61
Room 5
Tanforan,
San Bruno
May 18, 1942

Dear Jerry:

Thank you for all your kindness during Evacuation time and also for assisting Gyo to Washington University. We have received many letters from him saying how much he is enjoying his study there. I am glad that he was able to continue his study as I do not like to see him waste his time here in Camp.

I have been very busy sketching wild flowers which a friend from Berkeley brought to me and making sketches of camp life. Also I am extremely busy organizing an Art Department here. Within the past few days we have already had an enrollment of 231 students. We hope that we may be able to organize a good department here.

We are slowly becoming adjusted to this new camp life. The weather here is cool & windy and at times becomes hot. Mrs. Obata is in bed today with a cold. Yuri was also sick last week. We have a single room for the seven of us of size 19'x19'— Kimi & Masa, Mr. & Mrs. Sato, Mrs. Obata, Yuri & I. We have very little privacy or space but I still manage to sketch & paint. Will write again. Sincerely, C. Obata

Letter from Chiura Obata to Geraldine Scott,7
Tanforan, May 18, 1942

sinks in the laundry building with hot and cold water. There was no water, hot or cold, in our barracks. Laundry was supposed to be done together, but I didn't want to mix it with others.

At the dining room we had to bring our own plate, knife, fork, and spoon. I had packed them from home. I also packed chopsticks, which were quite handy. Every day we had to stand in line [at the mess hall]; people didn't want to be late because sometimes all the rice was gone. One time they served pork and beans, and Papa said in a big voice, "this is beans and beans!"

I remember a child saying, "I don't like Japan. I want to go home to America."

Tanforan Art School

In any circumstance education is as
important as food to a human individual
whether young or old.
CHIURA OBATA, 1942

At the time of the evacuation, Obata was fifty-
seven years old. He had been living in America
for thirty-seven years. Despite his personal losses
and the difficult conditions at Tanforan, Obata
refused to be dispirited. Since the day of his evac-
uation from the First Congregational Church, he
had decided to establish an art school as quickly
as possible.

While I was waiting for the bus there was a soldier
with a gun. There was a little child, five or six years
old, not knowing anything, with childlike innocence,
playing with the soldier—playing hide and seek at
the edge of the street trees. . . . Seeing that scene in a
situation where we were being forced into an unrea-

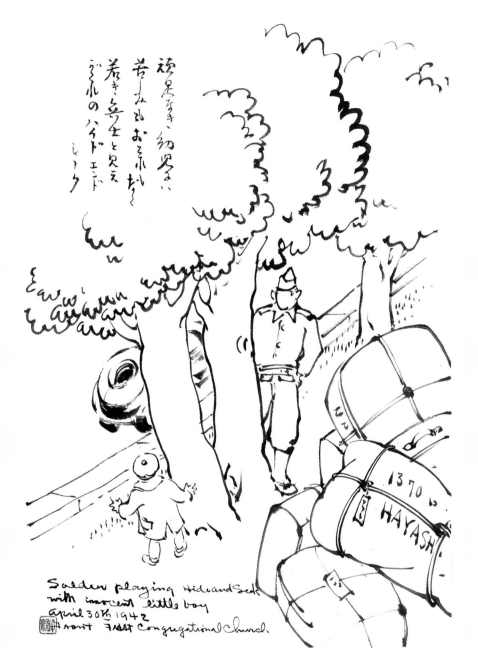

Soldier playing Hide and Seek
with innocent little boy
april 30th 1942
Front First Congregational Church.

**Soldier Playing Hide and Seek with
Innocent Little Boy**
Front First Congregational Church
April 30, 1942
Sumi on paper, 15¾ x 11 in.

*An innocent child, feeling no hardship
or fear, plays hide and seek with a
young soldier.*

sonable evacuation, to kill the burning heart, burning determination of these young people was very bad. Somehow we had to support the active, learning minds of the young people and provide them with a place where they could learn.

We were forced to artificially leave the land where we had lived and move into those stables in Tanforan. This was a kind of sin that was intolerable. From this sin, we had to bring these schoolchildren back to equality. We had to do something about it. My first thought was to open an art school and start teaching everyone. As soon as we got there I consulted with many different people.

Three days after his arrival, Obata applied for the affiliation of an art school with the Tanforan Adult Education program. As the director, Obata wrote the philosophies of the Tanforan Art School and its "determination to maintain one spot of normalcy." He firmly believed that the power of creativity would raise the spirit of his people:

Ever since Commodore Perry opened the gates of Japan almost one century ago we enjoyed the amiable relationship between this country and Japan.

Little did we dream that such a present situation can ever come to pass. The first generation, many of whom have passed through over forty and fifty years of hard struggle in this land through racial discrimination of the passage of the Exclusion Act concerning immigration, of act against purchasing and leasing of land and of excluding our school children in certain sections of the city. In spite of all this we have deeply appreciated the protection which this country offered us and of the endless and rich resources of nature in America, especially California. Record shows that there are but few families of Japanese on relief and also that we are law-abiding people. We have put every effort in bringing up our children to be good citizens of this country and we have educated them in most instances far above our financial means. A vocational survey made at Stanford University showed our people as having the highest record in professional training of any other comparative race groups. The majority of our children have become of voting age, and it was the deep desire of every parent that they serve this country. We wished to return service through our children (the Nisseis [sic]) but unfortunately due to this present situation

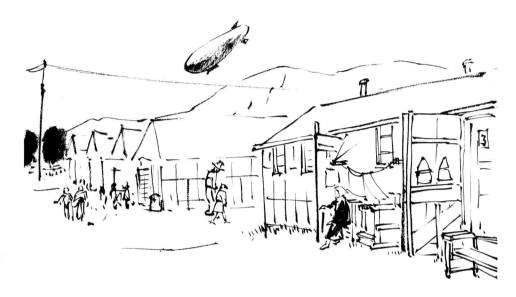

Goodyear Blimp Flying Over Tanforan
1942
Sumi on paper, 9 x 12 in.

all our hopes have been blasted to pieces. We are all interned into these camps. We are fed by the government three times daily in mess halls. We live in barracks of size 20 feet square, from one to three families in one of them indiscriminate of age or sex. We believed in the Freedom of America and that America was the land of the Free. We worshipped this highest attitude of Democracy as we look upward at a beautiful shining moon. But we became interned, having left behind our comfortable homes, careers and all our past experiences—everybody in camps without proper and adequate channels for mental and physical expressions. . . .

However, this is wartime, and there is suffering for everyone, and one cannot think of individual well-being only. We must all work together for greater constructive peace in the future. In order to bring out such peace we must educate all the people. We feel that art is one of the most constructive forms of education. Sincere creative endeavoring, especially in these stressing times, I strongly believe will aid in developing a sense of calmness and appreciation which is so desirable and following it come sound judgement and a spirit of cooperation. In such manner I feel that the general morale of the people will be uplifted. [1]

With the assistance of friends and graduates from UC Berkeley, plans for the art school were quickly put into effect. Once the staff had

Aoki *Obasan*[2], 83 years old
1942
Sumi on paper, 12 x 8½ in.

[Untitled]
1942
Pencil on paper, 12 x 8½ in.

obtained permission from the educational direc-tor, they posted thirty-two enrollment notices around the camp, even though they had yet to find a location for their school.

Finally, Mess Hall #6 was designated for the art school, and the staff set to work preparing the building. After cleaning, scraping, and dusting the muddy floors and windows, the teaching staff opened the school for registration on May 19.[3] The faculty included many recent college gradu-ates. Two had masters of architecture degrees, and three had masters of arts degrees, all from UC Berkeley, including Masao Yabuki and Mine Okubo (who would later publish a book of drawings detailing her life in the camps). The

sixteen instructors included Matsusaburo Hibi for painting, and later, Haruko would teach flower arranging. With the available talent, the curriculum included twenty-three courses:

Fine Arts

1. Figure painting
2. Landscape
3. Still life
4. Freehand brush work
5. Art anatomy
6. Sculpturing
7. Mural painting
8. Lectures on appreciation of art

Commercial Art

9. Fashion design
10. Interior design
11. Cartoon
12. Mechanical drawing
13. Architectural drafting
14. Commercial lettering and poster layouts

Techniques

15. Charcoal
16. Pencil
17. Water color
18. Oil
19. Crayon
20. Pen and ink
21. Pastel
22. Tempera
23. Black and white (sumi)[4]

The school's chief difficulties were the lack of funds and limited access to art supplies. The students were asked to contribute to the initial purchases for the school, rather than wait for an allotment of funds certain to be given low priority by the government, as outside opinion opposed "coddling" the internees. Obata solicited help from his students and friends in Berkeley, as well as from businesses and art schools. Generous contributions arrived from the American Friends Services Committee—sixty-six drawing pads, and crayons, pastels, and watercolors—and from Ruth Kingman, who sent 120 drawing pads and 300 watercolor tubes. The San Francisco Museum of Art, the First Congregational Church, Flax's Artist Materials, and Duncan Vail Art Supply Company all sent an assortment of paper and art supplies. Two super-

visors of the Elementary Art Education of San Francisco sent curriculum guides for lesson planning. The UC School of Architecture sent architectural magazines, drawing boards, and T-squares.

On May 25, just three-and-a-half weeks after Obata's arrival at Tanforan, the art school opened. Obata recalled:

The storm had started the night before, and on the morning after it was still raging furiously, and I was somewhat discouraged over the terrible gloomy weather. I took out my heavy fishing boots, raincoat, and rain hat, and I cut through the Tanforan Race Track along the eucalyptus tree groves. I saw rain puddles in many places and flood streams and a flying branch of eucalyptus tree playing dramatic scenes. Such scenes gave me fear and anxiety. I wondered if any students would be coming at all.

As I passed the old Tavern and came to the narrow path between Mess Hall #7, I looked over toward the art building and saw three tiny girls standing on the doorsteps of our art building. I ran to open the door. I noticed their little rubber boots and raincoats were drenched. In the mess hall art building there is an enormous cooking stove but no heating facility. I was afraid that maybe these little ones may catch colds. I ran out and went to a nearby friend who lives in a stall and asked for a couple of towels and wiped their cold heads and hands to warm them up. I asked the youngest girl (six years old), "Do you like to learn to paint?" With smiles and sparkling eyes she responded, "Sure I do!" "Who is your teacher?" I asked. "Mine Okubo," she replied. The older girls standing by remarked, "Yes, she's pretty. I want to learn from her too." In my heart, I thanked the mothers for their bravery in sending their beloved children even in such storms. I thanked Heaven for having started this movement."[5]

Once classes were underway, enrollment grew to over 600 students, ranging in ages from six to over seventy years old. Ninety classes were conducted per week, 9 a.m. to 9 p.m., Monday through Friday. The school was organized with five levels of instruction: elementary, junior high, high school, college, and adult education. The school managed to be self-supporting without administrative funds; students paid a fee of one dollar per adult, fifty cents per child. The registra-

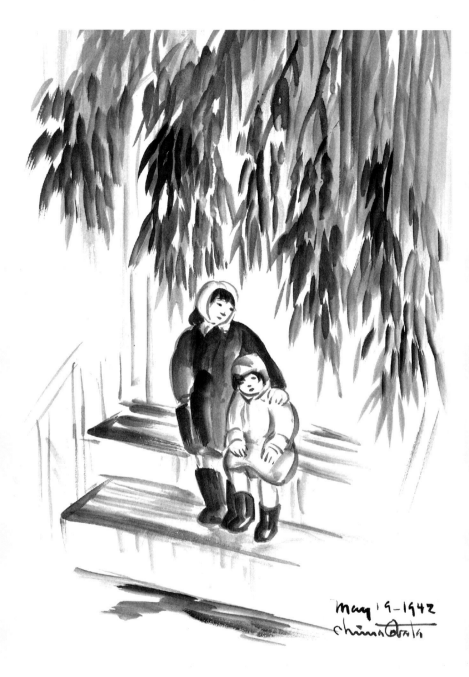

Two Angels in the Rain
May 19, 1942
Sumi on paper, 19¾ x 14¼ in.

[Young students of the new art school.]

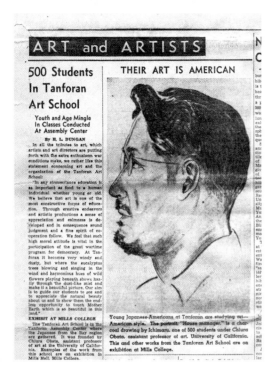

H. L. Dungan, "500 Students in Tanforan Art School," *Oakland Tribune*, July 12, 1942.

tion fees netted $600 plus $150 in personal donations, which nearly covered the expenditures of art supplies for the first ten weeks.

Mine Okubo remembered her work at the art school:

> I taught art in camp to children. I liked the children and students. It is a two-way learning—we learn from each other. Each one is an individual and needs individual attention. It was interesting. I remember the girls drew pictures about camp and camp life. The boys were more imaginative. Their pictures were on war, airplanes, circus, and subjects out of camp.[6]

Masao Yabuki's master's degree was delivered to him in Tanforan. He had been studying art under such notable UC professors as John Haley of the Berkeley watercolor school. He too enjoyed working at the art school:

> I had a classy job teaching kids. I ran the art department from seventh to twelfth grade; I had two assistants. They had their own classes, mostly seventh and eighth grades. What I taught, I told them: this is something you won't learn in high school. I'm teaching you as I was taught. The principle of drawing is "why." It's not how to draw; the main thing is "why."[7]

A month after the school opened, Obata arranged for a student exhibit outside the camp. Five sculptures and seventy-five drawings were exhibited at Mills College, the International House at UC Berkeley, and the Berkeley YWCA. The untiring efforts of Eleanor Breed of the First Congregational Church helped to bring the work to the public. Breed wrote to Obata:

> I feel I deserve no thanks at all—that I have gained some fine and courageous new friends through these visits at Tanforan. I feel very selfish about it—it

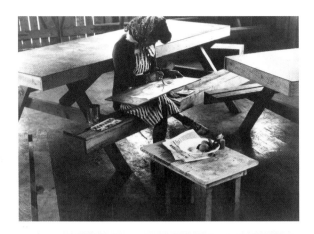

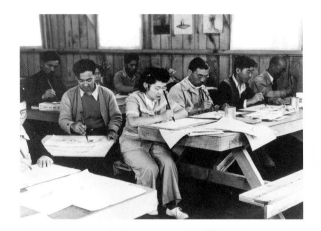

The still life class at Tanforan Art School.
June 16, 1942
Photograph by Dorothea Lange
Courtesy of the Bancroft Library
Banc Pic 1967.014:15HC-645

Chiura Obata's class at Tanforan Art School.
June 16, 1942
Photograph by Dorothea Lange
Courtesy of the Bancroft Library
Banc Pic 1967.014:15HC-646

seems just another indication of how askew these times are, that through something so unjust as mass evacuation I should find myself with some grand friends! Just doesn't make sense, does it? From another angle, though, everything I have done in connection with evacuees has been from a selfish angle—from a feeling of guilt that a thing like evacuation should have happened in this country of ours and that if all of us had worked harder at making democracy work, it wouldn't have— and from a hope that if I should someday find myself penned in behind a fence, under armed guard, there might be someone who would help a bit from the outside.

I'm glad if anything I did was of help to the school. I'm tremendously interested in the school and hope it will, through Mrs. Kingman and Dean Deutsch, find its way financially and continue its good work for keeping morale high. I'm sure it is part of the reason why Tanforan people had such sense of pride in all their accomplishments, and why, when I'd go down there for a visit feeling gloomy about the war and the evacuation, I'd come away with a lift and a confidence that the human race wasn't so bad after all. So long as it had people like the Obatas and Satos and Kajiwaras and Kunitanis and Marii Kyogoku and the rest in it. So you see you've helped my morale too![8]

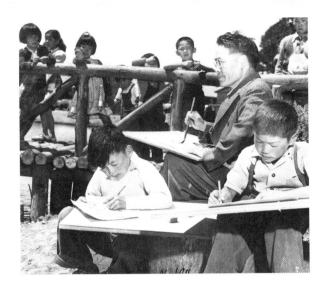

Obata teaching a children's art class,
Tanforan detention center, August, 1942.

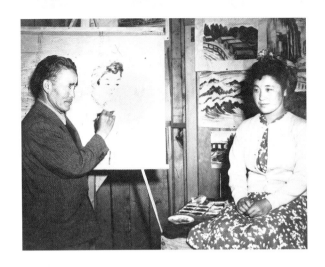

Chiura Obata, Tanforan Art School, 1942.

Obata conducted his sumi painting classes either in the mess hall facilities or by the Tanforan race track. While giving outdoor demonstrations, onlookers gathered to watch the paintings of plants and landscapes emerging from his brush. He was particularly happy with the class participation of the Issei, the people who had suffered such a great loss of physical possessions and personal dignity. The Tanforan Art School manual proudly listed a description of students who were first time art students, including:

> • *Mr. R. Kasai, 64 years old. Formerly a Tin dealer and Repairer in Berkeley for 12 yrs. and then*

operated a Floral shop in East Oakland for past 13 yrs. Had no training in art.
> • *Mrs. T. Kobayashi, 56 yrs. old. Wife of Japanese Divisional Commander of Salvation Army. No previous training.*
> • *Mr. Iwamoto, 76 yrs. old. Formerly a farmer but lately was day worker in S.F. No art training.*[9]

From July 11–14, the Tanforan Art School conducted an Art and Hobby Show featuring hundreds of the students' arts and crafts. The creativity and ingenuity displayed by the participants was a source of pride for the entire camp. The show recorded 9,000 attendees in four days, a number that reflected a high rate of returning visitors since Tanforan had fewer than 8,000 residents.

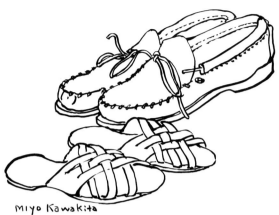

Miyo Kawakita
Rec. 4
Leather Works
Chiura Obata July 14, 1942

Leather Works
Rec. 4, Miyo Kawakita
July 14, 1942
Sumi on paper, 9 x 12 in.

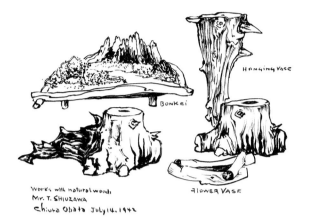

Works with natural woods
Mr. T. Shiozawa
Chiura Obata July 14, 1942

Works with Natural Woods
Mr. T. Shiozawa
July 14, 1942
Sumi on paper, 9 x 12 in.

Ninety percent of [the students] had no previous art training but the products displayed clearly indicated the natural creativeness of a creative people.
1) beautiful woven sun bonnets made out of tule grass which grows unnoticed in the insignificant corner of the camp; 2) making trays, vases, stands, and ornaments out of eucalyptus tree roots which have been discarded in dump yards; 3) ornate wood carvings out of old fence posts of the race tracks; 4) modern lamp and cigarette tray sets made out of junk auto parts which were found in the dump heap; 5) chairs and cabinets made out of fruit boxes; 6) about 400 model boats of all types.

Art training gives calmness. While handling brush to paint or handling chisel for sculpturing, the mind is concentrated to a single objective. Such concentration develops calmness of the mind and aids in good judgement for normalcy in any circumstances.[10]
CHIURA OBATA, 1942

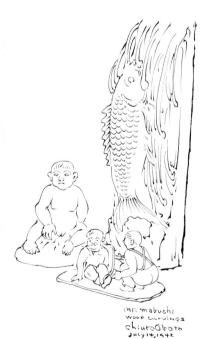

mr. mabuchi
wood carvings
Chiura Obata
July 14, 1942

Wood Carvings
Mr. Mabuchi
July 14, 1942
Sumi on paper, 12 x 9 in.

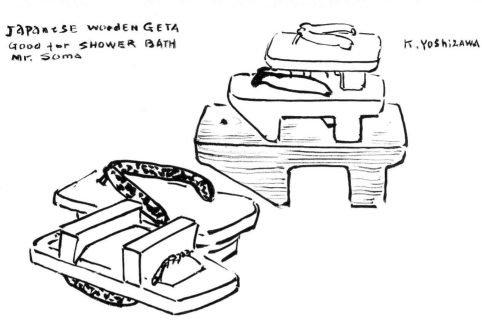

Japanese Wooden Geta
Good for Shower Bath
Mr. Soma, K. Yoshizawa

Chiura Obata
July 14, 1942

Japanese Wooden Geta
Good for Shower Bath
Mr. Soma, K. Yoshizawa
July 14, 1942
Sumi on paper, 9 x 12 in.

Grass Hats
Mrs. Yonekura
Hat woven by grass found inside this Tanforan
July 14, 1942
Sumi on paper, 9 x 12 in.

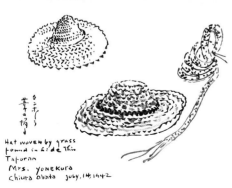

Hat woven by grass found inside This Tanforan
Mrs. Yonekura
Chiura Obata July 14, 1942

Mr. S. Yamamoto
Mr. M. Kimbara First Vegetable raised
Chiura Obata July 14, 1942

First Vegetable Raised
Mr. S. Yamamoto,
Mr. M. Kimbara
July 14, 1942
Sumi on paper, 9 x 12 in.

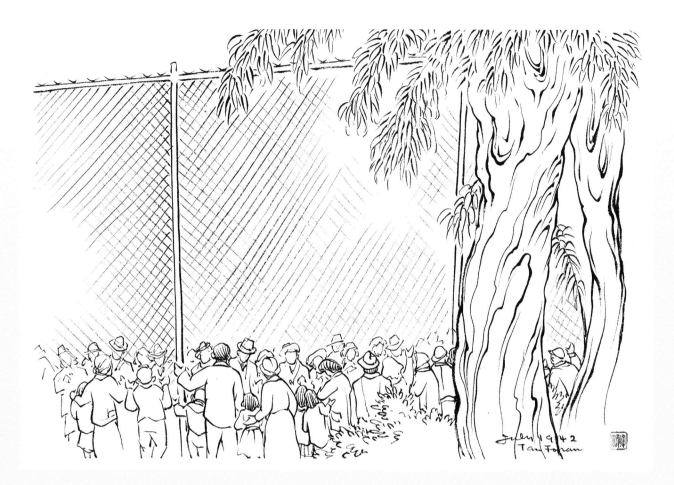

Talking Through the Wire Fence
Tanforan
July 1942
Sumi on paper, 11 x 15¾ in.

Obata described his position as director of the Tanforan Art School as "the hardest job of teaching I had ever had." His salary of $16 per month from the government was the standard rate for interned professionals, which could not exceed the GI salary of $21 per month.

Friends and students of the Obatas visited the camp not only to extend sympathy and provide

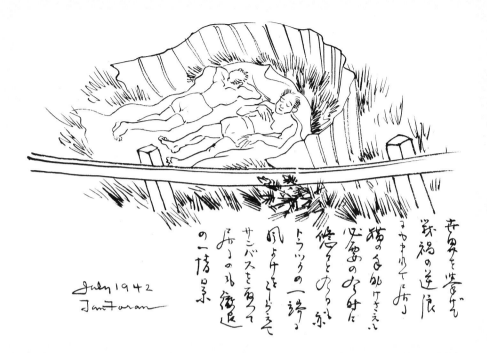

welcome gifts of food, but also to deliver art supplies for the Tanforan Art School. The strict security at Tanforan required that each visitor obtain permission to enter the camp; the guards even ran knife cuts through a cake before it was delivered to the Obatas. Geraldine Scott was one of the friends who helped the Obata family during their internment. "The war," she reflected in 1986, "brought out the worst in people and the best in friends."[12] In 1942 she wrote to Obata, explaining the difficulties involved in visiting:

> *We went down to Tanforan hoping to see you last Sunday. The line to get passes was very long and moved so slowly that we never got in and were most disappointed. . . . We had rounded up quite a lot of paper, charcoal, and other materials for your wonderful art school. We put them through the window and hope and pray that all the miscellaneous packages reached you.*[13]

Many visits were conducted standing at the cyclone fence on the camp perimeter. Haruko remembered "the public road was just outside this fence, and the cars seeing all the people would slow down, and the drivers would yell out their window, 'Hey Jap!' All the people were degrading us." She also recalled "the students from Berkeley [who] would come to Tanforan. They would say, 'Oh, how terrible, Professor

Tanforan

1942

Sumi on paper, 11 x 16 in.

In the middle of the Tanforan racetrack is a pond and a fountain. A dozen ducks lived there when we came. Now it is used for boating. This is an amusement for children; nevertheless, it is enjoyed by the Japanese who like to work with their hands. The finished work is very good due to their meticulous skill. Even a professional would be surprised. A middle-aged man is proudly rowing his boat as the ducks flee.

Obata, you are behind the fence!' They cried, poor things, so he would tell them, 'From my perspective it looks like you are behind the fence.'"

Haruko wrote, "whenever we have visitors, that fact that we are virtual prisoners is brought more forcibly to us."[14] The guard towers at Tanforan were also a constant reminder to the evacuees that they were living under military surveil-

lance. Beginning in June, they were subjected to daily head counts requiring that they be in their quarters twice a day: once in the morning and again at 6:30 p.m. Twice the FBI held a campwide search inspecting each barrack for contraband.

Apparently, the activity generated by an elder Issei like Obata raised suspicion, albeit short-lived, in the Division of Internal Security at Tanforan, as noted in this confidential report:

> Obata, Chiura. Tanforan A.C. File #000-31 06/22/42 Suspected of subversive activities. Name given by Officer Ferbrache of Interior Police, TA AC, but after investigation, found him to be former art instructor of University of California and world renown [sic] painter.[15]

The Tanforan Art School had two more art exhibitions before closing in September. An Issei painting student wrote the following letter on the final day of the last exhibition:

> Tanforan, September 7, 1942
>
> To Obata sensei[16]
>
> I lived in Japan for nineteen years. For the past thirty years I have become one of the American people, and I have had a continuous struggle with life. Because of the effect of this war I was treated as an enemy alien from the Americans whom I do not think of as my enemies. I became a captive at Tanforan, abandoning everything that had been going well for me. I was in despair over this meaningless experience.
>
> By recommendation of a friend I began to study painting under Obata sensei then I began to feel that I have found a place of calm. At the same time I began to feel that I got out of the world filled with rumor and evil thinking, and I thank God. This is due to Sensei's charm that comes from the spirit of brush painting and his enthusiastic teaching. I made up my mind that whatever will happen in the future and however hard I have to work, I will never lose this spirit of painting. I will live sincerely and beautifully with my friends. I believe this is a meaningful life not only for myself, but also for people and society. From, Maeda[17]

On September 9 the first work party of internees left Tanforan for the Central Utah Relocation Center, a concentration camp isolated in the Utah desert. Although this camp would be under the civilian administration of the War Re-

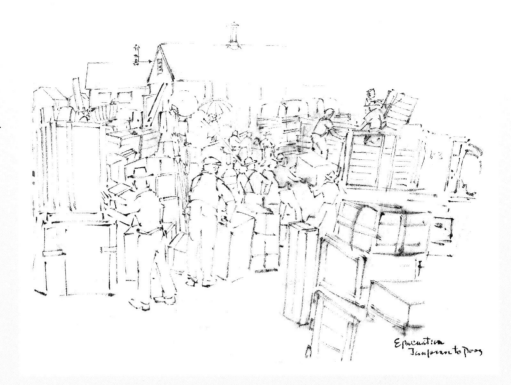

Evacuation
Tanforan to Topaz
1942
Sumi on paper, 11 x 15½ in.

location Authority (WRA), the perimeter would be guarded by the military. Once again the evacuees packed their belongings for a departure to an unknown place. The furniture and shelves they had built from scrap lumber upon their arrival at Tanforan now became packing material. Matsusaburo Hibi's wife, Hisako, recorded the experience in her diary:

September 16. Wed. Very busy making boxes, crating for the freighter. Everyone looks at the box Hibi made and gives a big laugh and all kind of criticism. We took off the shelves and used the wood for boxes.

Mr. and Mrs. Chiura were here and they insisted that the Hibis' boxes will not pass inspection. Around 8 o'clock Mr. Chiura brought a big box for us. He must carry it himself, and it is pretty heavy one. We were thankful. It took us till 11:30 night to pack.

September 17. Mr. Obata and Mr. Yanaba helped to make Hibi's box stronger. Everyone is hammering.[18]

Topaz

We are in the middle of a world war. What is our hope? What is our goal? . . . The highest aim and hope of art is a high, strong peace. In front of this high aim the evil side of humans—including racial discrimination, egotism, selfishness, and hatred— are simply exposed.

CHIURA OBATA, 1943

The Obata family's five-month stay at the Tanforan detention camp ended on September 22, 1942, when they were transferred to the "permanent" camp in central Utah. At that time, daily trains left Tanforan carrying over 500 evacuees under armed guard. Once again, Obata detailed the process in his sketchbook.

As the train traveled through the Sierra Nevada Mountains, Obata saw the familiar scenery he had sketched for countless summers. His painting of a clear mountain stream and its surroundings, "Feather River Canyon" [page 116], was lovingly depicted in bright colors, in sharp contrast to his other internment art. His sketches of the train

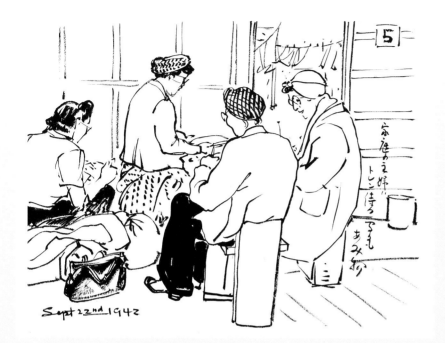

Sept 22nd 1942

Women Knitting
September 22, 1942
Sumi on paper, 8 x 11¼ in.

Housewives knit even while waiting for the train.

[Haruko Obata, seated second from the left,
waits in the barracks with her daughter-in-law and
friends on the day of departure from Tanforan.]

September 22, 1942
Sumi on paper, 9 x 12 in.

*Their baggage packed, they play go in
the street while waiting for the train.*

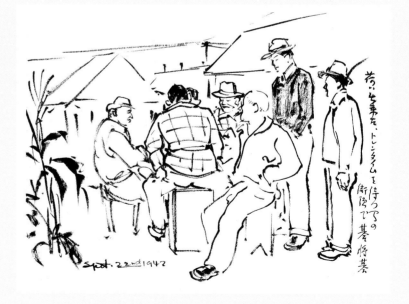

Sept. 22nd 1942

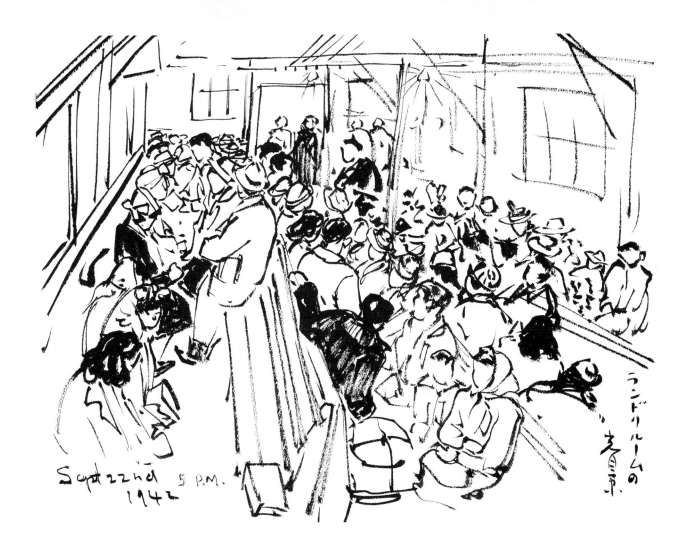

Gathering in the Laundry Room
5 p.m., September 22, 1942
Sumi on paper, 8¾ x 11¼ in.

Placerville
6:30 a.m., September 23, 1942
Sumi on paper, 9 x 12 in.

Placerville dawn
Reddish earth, autumn colors
Thinking about the young girl O-Kei

[O-Kei Itō lived near Placerville. In 1871 she was the first Japanese immigrant woman to die in America.]

Gerbuck
3 p.m., September 23, 1942
Sumi on paper, 9 x 12 in.

Hot, deserted town

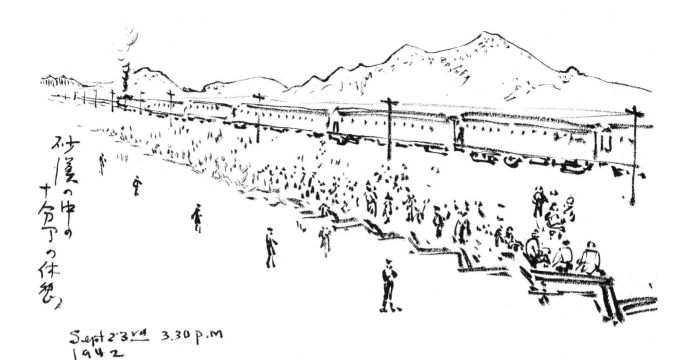

砂漠の中の
十分の休憩

Sept 23rd 3.30 p.M
1942

In the Desert, a Ten Minute Break
3:30 p.m., September 23, 1942
Sumi on paper, 8¾ x 11¼ in.

In the middle of the desert everyone could leave the
train to stretch. They think somebody wants to run
away, but nobody wants to run away in the desert.
How could we? No food, no train or anything.
HARUKO OBATA, 1986

Vast Sagebrush, Blue Green River
4 p.m., September 23, 1942
Sumi on paper, 9 x 12 in.

Winnemucca
6 p.m., September 23, 1942
Sumi on paper, 9 x 12 in.

Southern Shore of Salt Lake
9:20 a.m., September 24, 1942
Sumi on paper, 9 x 12 in.

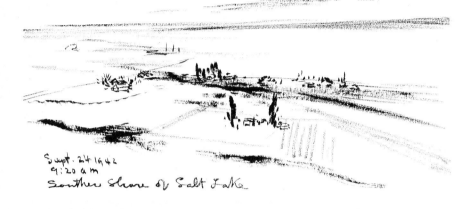

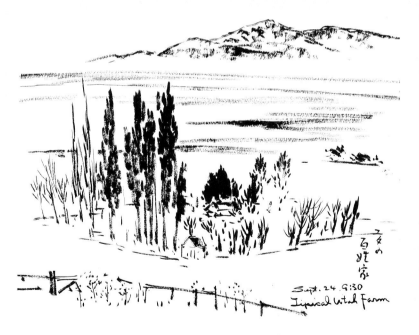

Typical Utah Farm
9:30 a.m., September 24, 1942
Sumi on paper, 9 x 12 in.

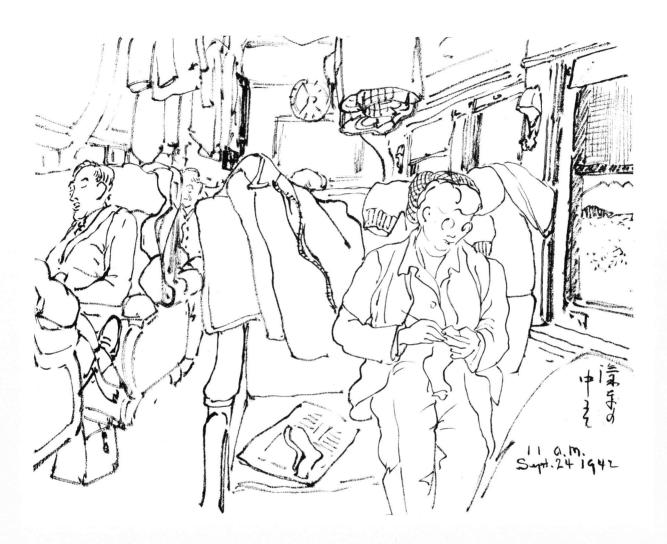

In the Train
11 a.m., September 24, 1942
Sumi on paper, 8¾ x 11¼ in.

[Haruko Obata sits by the window knitting a pair of socks. In 1986 she said, "This train so old! I never saw such an old train. The carpet was threadbare. There was just one lamp. It never go fast. So slow: 'gata-goto' (rattle along). I never saw such an old train in all my life."]

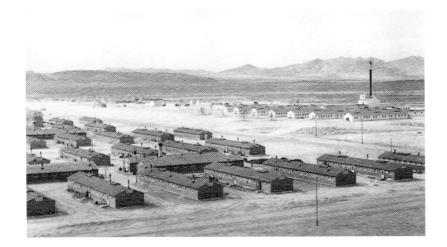

Topaz War Relocation Center, Utah, 1943. The Topaz Art School is the barrack in the foreground on the far right. In the distance are Topaz and Drum Mountains. Photograph courtesy of Eleanor Sekerak, Topaz Museum, Delta, Utah.

ride recorded each passing scene: the desert towns, the brief exercise break outside the train while guarded by a line of soldiers, and the vast Nevada and Utah landscapes [page 117].

Their new home was named after Topaz Mountain that rose in the distance above a wide, bleak desert. "We couldn't see anything growing except weeds," recalled Haruko, "It was the first time I ever saw a place like that." The severity of the weather alone plagued the internees for the duration of their stay. Matsusaburo Hibi recalled, "When we arrived at Topaz, it was quite hot and dusty; and when the wind blew, dust covered the whole mile-square camp.... The world was covered only with gray color, and we felt that we were dumped en masse into a desert where only scorpions and coyote were living."[1]

Scorpion
September 1942
Watercolor on paper, 9 x 12 in.

The Hibi family had arrived three days earlier, and they anticipated the arrival of the Obata family. Hisako Hibi wrote:

Sept. 24. After the breakfast we went to the waiting place and waited for the Tanforans, among them Mr. Chiura's family is coming. Nobody arrived until after 2:30 p.m.... We waited a whole morning but they did not show.... The first bus arrived from the

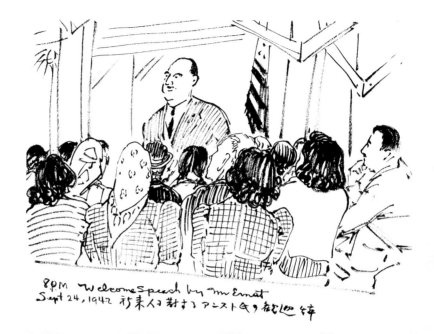

**Welcome Speech by Mr. Ernst
for the Newcomers**
8 p.m., September 24, 1942
Sumi on paper, 9 x 12 in.

8PM Welcome Speech by Mr Ernst
Sept 24, 1942 新来人ニ對スル アニストの歓迎辞

*Delta, then 2nd, 3rd, and on the 4th bus we saw
Mr. Chiura's family. Mr. Niwa, Katherine, and I
helped to clean Mr. Chiura's new apt. They reside
block 5, Bldg 9D. They said they had a hard trip
and were on the train forty-two hours.*[2]

For the next several days Obata chronicled
the arrival process from the nearby town of Delta
to Topaz with more sketches. On October 8 the
evacuees from the Santa Anita detention camp
arrived and were assigned barracks not yet
habitable. Obata wrote:

*The desert winter: you can feel the weather getting
colder day by day. At 2:00 a.m. at night, in the rain,
the people from Santa Anita arrived. The barrack*
*was incomplete, without lights. There were beds but
no mattresses. They trembled with fear in the dark-
ness. Their destiny: a fight against snow and frost.*

For the internees there was a constant battle
with the powdery alkaline dirt that lay exposed
on the ground after camp construction had re-
moved all vegetation. There was no protection,
even within the barracks, from the dust storms
that engulfed the camp. Haruko recalled:

*The dust storms in Topaz were terrible and made
an awful noise. Even indoors we wore scarves and
masks because the dust was like a fog in the room.
The rooms weren't built well so the dust came in the
cracks and crevices under the doors. How could they*

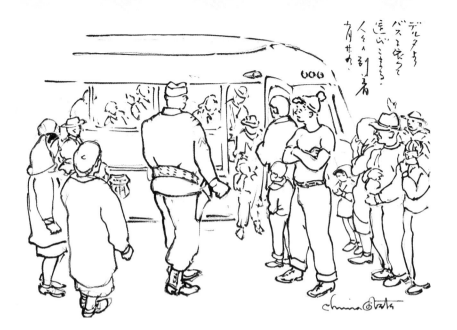

デルタより
バスを使って
運ばれてくる
人々の到着
有本

Arrival from Delta
September 29, 1942
Pencil and sumi on paper, 8¾ x 12 in.

The arrival of people transported by bus from Delta.

Topaz at Last
9 a.m., September 29, 1942
Pencil and sumi on paper, 9 x 12 in.

Two days, two nights on the train. From Delta they crossed the desert by bus, finally arriving at Topaz Relocation.

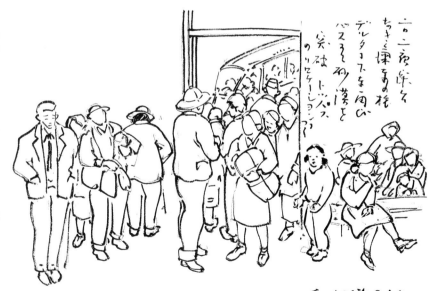

二夜
ちきく揺
デルタ
バスを
安堵
リロケーション

Sept 29 9. A.M.

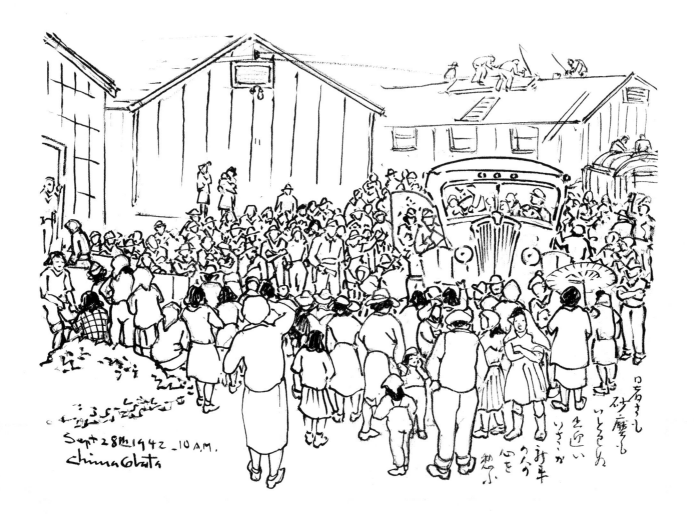

A Gracious Welcome

10 a.m., September 28, 1942

Pencil and sumi, 8¾ x 12 in.

In spite of the heat and dust, members of the center welcome the new arrivals.

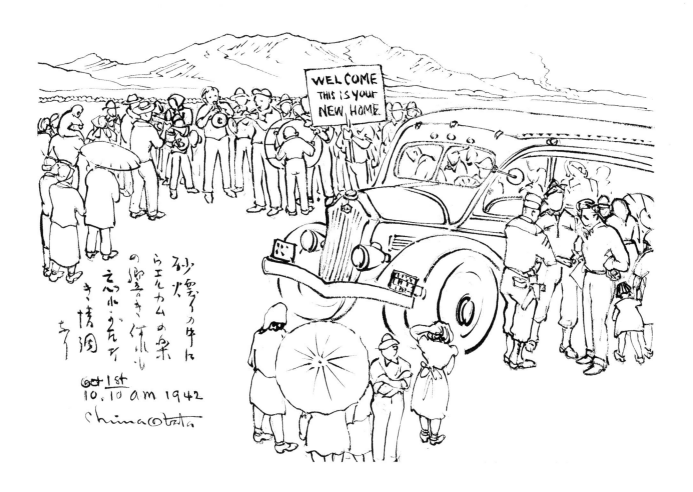

砂煙の牛に
らエ九カムの栗
の聲なき休み
それ水うえて
き憬洞

Oct 1st
10.10 am 1942
Chinae Otota

The Welcoming Band
10 a.m., October 1, 1942
Sumi on paper, 9 x 12 in.

In the dust storm there is the unforgettable music of welcome.

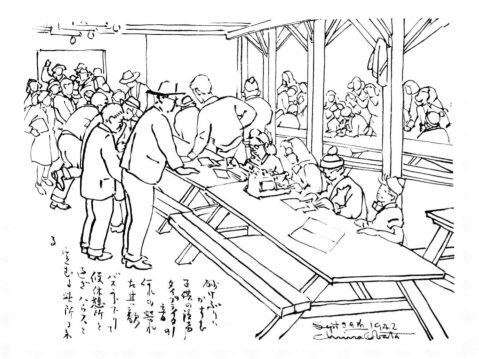

Housing Office at Topaz
September 29, 1942
Pencil and sumi on paper, 9 x 12 in.

The crying of children muffled by the dust storm. The noise of the typewriter and the weary faces. From the bus to a temporary resting place. Then, the registration for housing.

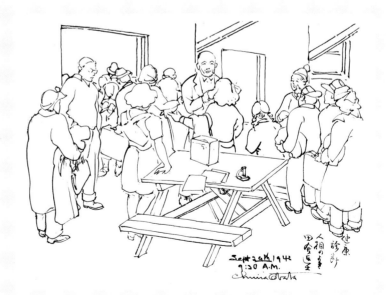

Examination Time
9:30 p.m., September 29, 1942
Sumi on paper, 9 x 12 in.

Physical examination. Country doctor's face is kind.

First Impression
10 a.m., October 1, 1942
Sumi on paper, 9 x 12 in.

The mountains of Topaz are covered with a purplish blue haze. The sky clears; is it sufficient to comfort the people arriving today?

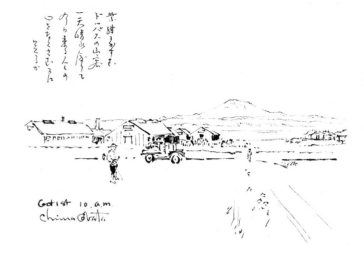

Newcomers from Santa Anita
October 8, 1942
Sumi on paper, 16 x 11 in.

make us live in such a terrible place? Papa called me a human vacuum cleaner. I had to clean constantly. Even though we closed all the windows the dirt would accumulate on the window sill. It was really awful when the storm came.

As in Tanforan, Obata met with administrators to establish an art school. Obata was appointed art director, and Recreation Hall #7 was designated the school headquarters on October 5. Volunteers immediately cleaned the building, and the school opened the following day.

Hoping to gain further administrative support and funds, the Topaz Art School held an arts and crafts show less than two weeks after the school's opening. Obata wrote to Eleanor Breed:

We have experienced the most horrible sandstorm

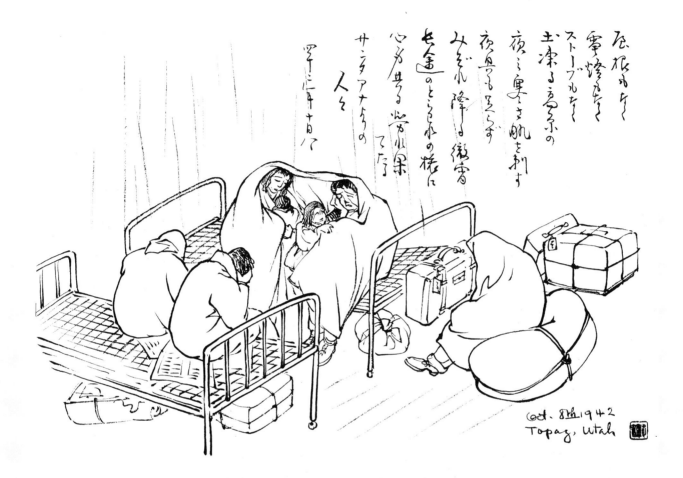

屋根もなく
電燈もなく
ストーブもなく
土凍る高原の
夜ゝ寒き肌を刺す
夜具さも足らず
みぞれ降りし徹宵
もの金のとらる木の様に
心も萎る當の小果に
サンタアナからの
人々

昭和十七年十月八日

Oct. 8th 1942
Topaz, Utah

A Sad Plight
Topaz, Utah
October 8, 1942
Sumi on paper, 11 x 15¾ in.

No roof,
No electricity,
No stove.
The ground is frozen at this elevation.
The cold pierces the skin.
The rain has become sleet
And not enough bedding.
Forced to travel,
Broken in mind and spirit
Are these people from Santa Ana.

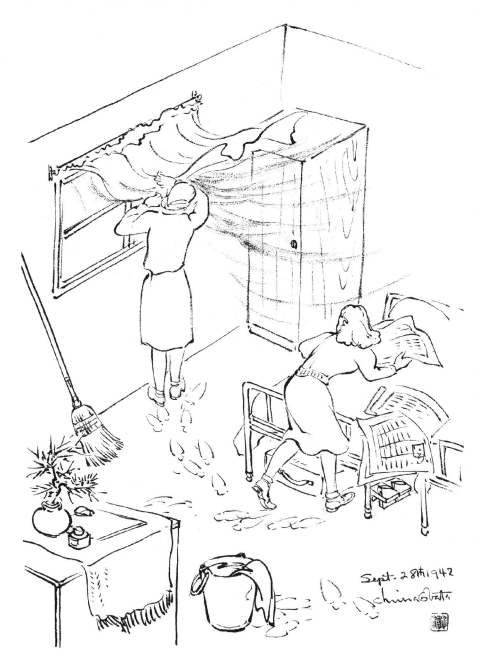

Dust Storm in the Barracks
[Haruko and Yuri Obata]
September 28, 1942
Pencil and sumi on paper, 15¾ x 11 in.

The window is sealed with "gum paper." Everything from the bed to the desk has been randomly covered with any and all available newspaper. Yet, the smoky dust comes pouring through the cracks of the chimney, floor, and ceiling. Due to this hellish, burning smoke, one in desperation looks for the direction of the wind. When the window is even slightly open, this crazy wind with its ferocity wears out the women to exhaustion. They take pains to sweep the floor, change buckets of water a number of times only to mop again. Finally they are now about to take a moment's rest and gaze upon the floor.
CHIURA OBATA, 1942

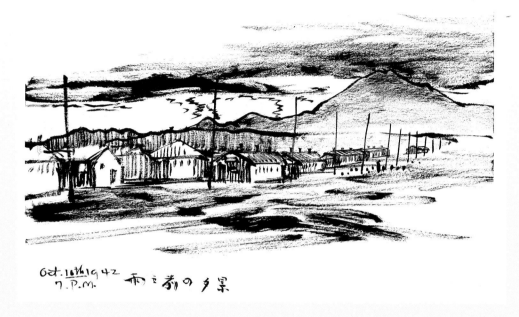

Evening View Before the Rain
7 p.m., October 10, 1942
Sumi on paper, 9 x 12 in.

At the end of a hot depressive day the air hangs heavily over the rows of camp barracks.
CHIURA OBATA, 1946

at that time. *It was a disappointment to all the residents of this city. I always said to my students, "through crying and complaining one will never produce anything but a nervous breakdown," so you can see that such a show will help keep up the morale.*[3]

The 350 Topaz Art School students were part of the Adult Education Program, which, by December, had 3,250 students studying music, flower arrangement, sewing and knitting, English, mathematics, and other evening classes. Besides the Obatas, the Topaz Art School instructors were Matsusaburo and Hisako Hibi, Frank Taira, and Teruo Iyama, who had all studied at the

California School of Fine Arts; Byron Takashi Tsuzuki, who had studied at the Art Students League in New York City; Henry Fujita, who taught classes in fly-tying; and Chiyo Shibaki, who taught leather craft. The dedicated staff struggled to maintain as high a standard as possible. Matsusaburo Hibi wrote:

The Topaz Art School of today is inferior to the usual art schools in America . . . but nevertheless we believe it is superior in some respects. Our Art School is so well harmonized between teachers and students that, although the ages of the students range from five years to sixty-five years, the existing relationship is like that of parents to their children. The

Dec 15 42

Dear Mr Obata: My friend, Ray Strong, gave me a package of art materials, asking me to send them to one of the Relocation Centres, as his contribution to aid some Japanese artist, who might be hindered in his work through lack of material. So I am mailing this package to you Today, since I know that you will be able to give it to a student, or for use in the school, anyway that you see fit.

Be of good cheer. you are not forgotten — and let us know if there is anything we can do to help

Sincerely your friend
Dorothea Lange Taylor

Chiura Obata
Block 5 Bldg 9 apt 1)
Utah Relocation Centre
Topaz, Utah

Letter and envelope from Dorothea Lange
to Chiura Obata, December, 1942.[4]

work of the students is progressing wonderfully, and some are good enough to be hung in any present day museum.[5]

In November, as winter approached, Obata wrote to his friends:

The housing here is still unfinished, and at present they are installing the inside walls of the apartments. After such things are done, we will have a long winter ahead of us. I heard that it will be twenty-five to thirty degrees below this winter. No one will be able to work outside on the project. On the other hand, 80 percent of the residents in the past have lived in the city. These people show great ability in handicraft; that is why I am trying hard to establish Art Craft [sic] in connection with Industrial Art. Unfor-tunately, the Adult Education Department does not have sufficient funds to meet my budget. That is a bit of a stomachache for me and not a headache.[6]

I find the scenery here very beautiful. The colors of the sun in the morning and evening are something very different from those we see in the Bay Region. It is getting colder every day, and even at nine o'clock in the morning, when I have one class, my water-colors freeze on the paper. We have a couple of coal stoves, but it is not sufficient to warm up the hall that we are now using as our art school.[7]

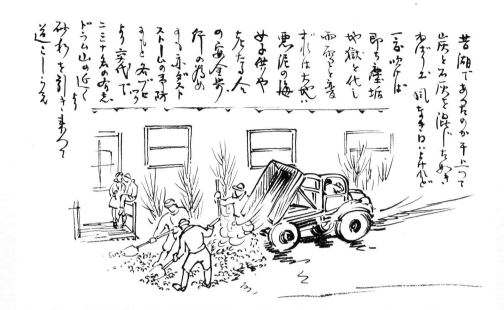

Fixing the Road
1942
Sumi on paper, 11 x 16 in.

An ancient lake had dried and looks like a mixture of charcoal and lime, therefore the earth is sticky. It's fine if there's no wind, but if it's windy everything becomes dust. It's like hell. If there is rain or snow the ground turns to mud. For the safety of women and elderly people and for protection against dust storms, twenty or thirty people from each block volunteered and brought gravel from the Drum Mountains to repair the road.

Living in their barrack facilities the Topaz residents endured the severe winter as best as they could. Recalled Haruko:

> The winter was so cold; the moisture on the ground froze to ice, and your footsteps made a crackling noise as you walked. When we went outside to use the bathroom, we wore all kinds of warm clothes and ran back to our room. The wind was so strong. You can't move. You can't walk. You'd never think desert country was like this. To take a shower we had to walk about one block. When the wind blew so much I told Yuri, "You better put the towel over your face," and we bent over, almost crawled, because the wind was so hard. I fell over twice. Having no indoor toilet was awful. Just thinking about it makes me cringe [page 120].
>
> In our rooms we burned newspaper and wood in a potbelly stove to keep warm. From the central coal pile we could take what we wanted and carry it home in a bucket. Mrs. Ito used to clean house for me in Berkeley; when she saw me hauling the coal she grabbed the bucket out of my hands. I told her she no longer works for me and that we were equals in camp, but she refused to listen and took the coal home for me.

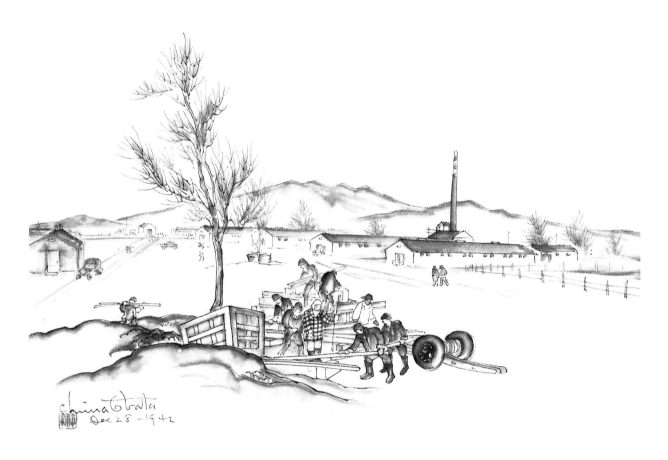

Transplanting Trees from the Mountains to Topaz
December 28, 1942
Sumi on paper, 10¼ x 15¼ in.

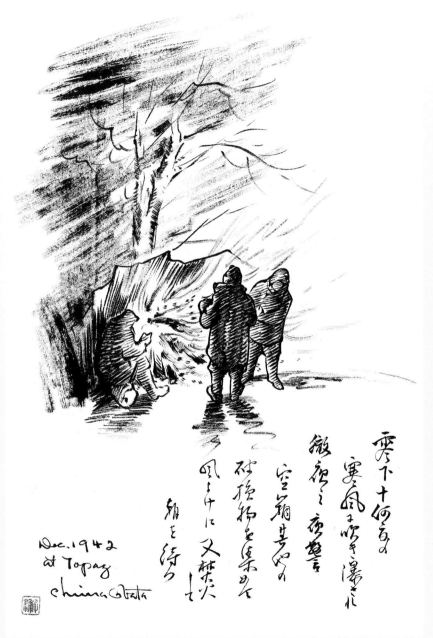

Night Patrol at Topaz
December 1942
Sumi on paper, 16 x 11 in.

It's more than ten below zero
Staying up all night to patrol
Waiting for the morning
They collected boxes
for protection from the wind
and to make a fire.

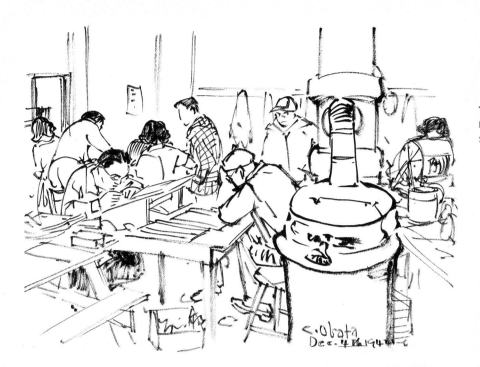

The Topaz Times in Production
December 4, 1942
Sumi on paper, 9 x 12 in.

Pig Farm at Topaz
Topaz W.R.C.
December 1942
Sumi on paper, 11 x 16 in.

Nagare no Tabi[8]

Topaz Times New Year Issue
January 1, 1943
Mimeograph, 14 x 8½ in.

1. *Under the spring rain, our fateful journey began from Berkeley, California. Our destiny after "Pearl Harbor" was to be determined by a Higher Power—who could foretell our fate? Now, looking back, we feel nostalgia as we see the panorama of the past eight months of our life.*

2. *While buses carried us across the great San Francisco Bay Bridge, we caught a glimpse of the San Francisco skyline silhouetted in the rain. We felt a tug in our hearts as we bid farewell to the familiar surroundings to which we had become so attached.*

3. *We waded in rain, through slush and mud up to our knees, only to stumble into empty horse stalls. Many an involuntary sob escaped our lips as we began our life at Tanforan.*

4. *The spirit of ten thousand people, however, could not be crushed for long. Presently, we made our own way of life among ourselves and found a bond of attachment with everything around us. But our journey was not yet over. We were soon to say farewell to the community we had helped to build and to the familiar grandstand which towered above.*

5. *Good-bye, California! Good-bye to our beloved mother state. Our last adieus were said as we sped past the beautiful Feather River.*

6. *Hello, Utah! But how dry and wild the desert country is! Resting beside the railroad, we girded our spirits and prepared ourselves for our coming life.*

7. *The desert dust storm! Barracks, rooms — everything, everywhere was sunk in darkness! But not so our hopes and determination to conquer nature's violence. We looked up, and there, as if in answer, not fifty feet above us we saw the pure blue of the skies.*

8. *Four months of hardship have passed. Our strong hopes and iron will to succeed have never wavered. At last, we see the beautiful dawn as reflected in the morning sun bright against snow-covered Mt. Topaz!*

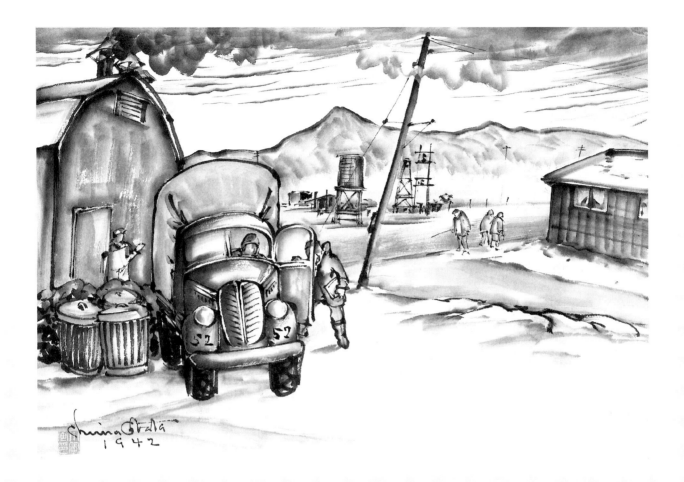

Commissary Truck
1942
Sumi on paper, 13 x 18 in.

Mr. Hughes and Mr. Watson has confirmed me [sic] that you could make arrange-
ments for me to have one of the bread delivery trucks from Salt Lake City take a
large painting to Salt Lake for exhibit. The painting is crated in a box 58" x 34".
CHIURA OBATA, LETTER TO COMMISSARY DEPARTMENT, FEBRUARY 10, 1943

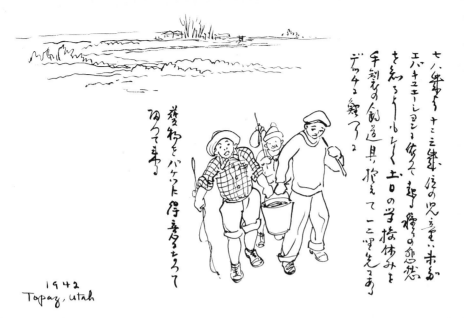

七八年を十二三歳位の児童は来か
エバキュエーシヨンを知らて
を知ろと小さく土口の学接休みを
手判その飲送具捉ゑて二瓔先っあ
デッチャ翼了る
廃物をバケツに停著多ちって
田って米す

1942
Topaz, Utah

Topaz, Utah
1942
Sumi on paper, 11 x 16 in.

School children about seven to thirteen years old didn't understand the miserable conditions of the evacuation. There's no school on Saturday, so they went four to eight kilometers from camp to fish with hand-made poles for carp in the ditch. They're returning proudly with the fish they caught.

War Tragedy
1942
Pencil and sumi on paper, 11 x 16 in.

"Today is good weather, so I can't waste time. I had a good time with my friends in San Francisco and San Jose. Last year I built a big barn. I should plant my vegetables and eggplant." Old man about seventy-five years old from Venice in the south.

An old farmer who, under the strain of war conditions, lost his mind while in Topaz.
CHIURA OBATA, 1946

At Topaz Mountain

1943

Pencil and ink on paper, 7 x 4½ in.

The War Relocation Authority offers six trucks every Sunday in which 150 evacuees can go on a picnic. There are many topaz stones here, mostly white. Collecting unusual trees, bonsai-like greasewood, unusual stones, and topaz gives relief from the meaningless barracks life. The surrounding Great Nature, which hasn't been paid attention to since the Mormons came, is brought to new life by our relocation here.

CHIURA OBATA, 1943

In December, H. L. Dungan, art critic of the *Oakland Tribune* and a personal friend, wrote the following letter to Obata:

George Kondo wrote to me from Topaz, asking for advice. I told him to see you, to walk with you at dawn for an hour, and in that hour you could tell him more about how to live with honor, decency, and kindness than I could in ten years. Not that I am not a decent fellow, but George couldn't wait ten years for me to tell him what you could do in an hour. When I suggested this perambulation I didn't realize that Topaz is a bit chilly at that hour.[9]

During the winter, Yuri, a student at Topaz High School, found it particularly amusing to see many evacuees wearing the same clothing: navy blue pea jackets distributed by the WRA and outfits ordered from the Sears Roebuck catalogue. When Gyo spent Christmas with his family in Topaz, he was surprised to see how sun-browned his family had become in the desert environment.

Obata was a recognized figure within the Topaz community. He found the Topaz administration generally favorable to the residents' welfare, but he remained critical of the lack of improvements. In January, the interned nationals

Entrance to Obata Dwelling in Topaz
November 1942
Sumi on paper, 11 x 15¾ in.

All the families did some gardening about their dwellings in order to beautify them. Everything had to be brought in from the mountains: rocks, trees, and shrubs.
CHIURA OBATA, 1946

were given the opportunity to air their grievances to the Spanish Consul, whose role was mediator to the Japanese government. In Topaz, a group of concerned Issei—headed by Obata—gave living conditions a high priority, asking that there be "the quickest possible adjustment of all abnormal housing conditions so that not more than one couple, and no single men and women, be housed together in the same room. This we ask on the basis of universal principles of health and morality."[10]

Excursions into the surrounding foothills in

Army trucks provided a welcome relief from the barracks life. Groups would search for topaz, arrowheads, and trilobite fossils or collect twisted greasewood trees that resembled bonsai. Back in Topaz, the raw materials were used to create decorative crafts. The Obatas were among those residents who constructed a garden of shrubs and stones to add grace to the barrack entryway.

During this time, Obata was sustained by his conviction that nature would always provide inspiration:

As you know, I'm a painter. Although we were in

Topaz, Utah

1942

Sumi on paper, 11 x 16 in.

In the Utah mountains there are old trees
with unusual shapes similar to cypress.
They can be used for decorative pieces,
stands, or ashtrays.

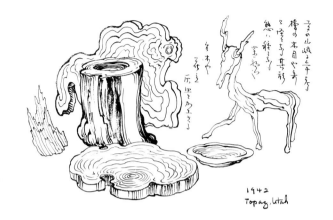

1942
Topaz, Utah

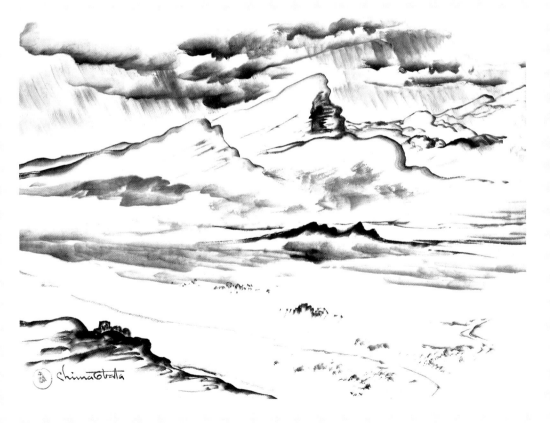

Outside of Topaz

ca 1943

Sumi on paper, 15 x 20 in.

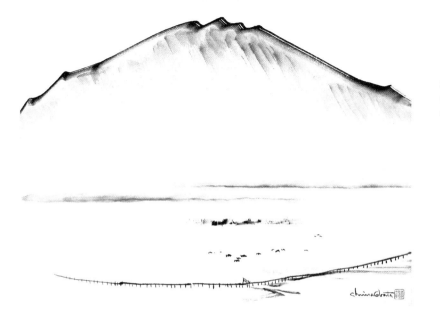

Big Pasture, Utah
1943
Sumi on paper, 13 x 18 in.

the huge seventy-five miles wide Sevier Desert, in a place where almost no living thing exists, if you look far into the east you have the Rocky Mountains, a grand mountain with snow on top. If you look in the [northwest] you have Topaz Mountain. In between, the rising sun in the morning and the sunset is very calm, with a complex mixture of color that is beyond description. I feel profound gratitude for these things, and in that sense, to put it briefly, I did not feel abandoned. Instead, I learned a lot. If I hadn't gone to that kind of place I wouldn't have realized the beauty that exists in that enormous bleakness [page 124].

In his New Year's address to the Topaz Art School he stated:

Even though we must spend our days in the middle of a desert, each day is a precious day that contributes to our life and will never return. Half a year or a year can go by as quickly as a dream. If we spend our time listening to rumors or indulging in gossip at a time like now, what can we achieve? Have we noticed the beautiful mountains surrounding us that have existed for thousands of years? They show heaven and earth their greatness. They can't be moved no matter how many people try. The sun and the moon have been shining for tens of thousands of years blessing the world. The mountains, moon, and sun never try to explain. Whenever dark clouds hide the sun, the clouds will shine with the golden color of the sunlight. At night they will be

Sevier Desert

1943
Sumi on paper, 14½ x 10 in.

The spring has come, but here in Topaz there is not even one green, growing plant.
Everything is like it is drawn with a grey brushstroke.
Yellow dust blows into eyes, mouth and skin.
It is not known how long we will stay in this desert.

Vase
Haruko and Chiura Obata
Carved wood, height 11¾ in.

One day Papa and I said we like to have just one firewood before you chop. They had a nice machine to cut it where I made marks. It was dirty on the outside, and we didn't have sandpaper so we just used paper. Then someone sent us a box of walnuts. When I was a little girl my grandmother used crushed walnuts tied in an old cloth for polish, so I wound up the walnuts in an old handkerchief. It made the wood so nice. We found a big nail and beat it with a hammer to make it flat, so we made a sharp thing. At night we used a burning coal with the nail to dig the center. Every night it was a big job. I can't do it so Papa helped. Little by little we made the vase. The vase—it looked so nice. I still use the vase for ikebana.
HARUKO OBATA, 1986

blessed by the moonlight decorating their edges with a silver line. We only hope that our art school will follow the teachings of this Great Nature, that it will strengthen itself to endure like the mountains and, like the sun and the moon, will emit its own light, teach the people, benefit the people, and encourage itself.

In January, a second branch of the Topaz Art School opened at Recreation Hall #37. Obata explained in a letter to Jack Boylin, a former student:

Last week we opened a new branch of this school, so that residents who live on the other side of the city can attend classes. You see, our present school is situated in one corner of the camp and is quite a distance for some people to come to school—especially hard to attend when we have storms as the ones we are having. [11]

Haruko was one of four ikebana teachers in the camp. It would require all her imaginative resources to find the proper materials for her classes. In desperation Haruko once asked her students in Berkeley to mail camellia branches. Haruko explained that she would pay the postage and that the flowers were unnecessary as she and the students would attach paper flowers to the branches. She wrote to a friend: "Since fresh flowers are not available here I am making crepe paper flowers for the students in my Flower Arrangement classes. It must be beautiful in California now with the green grass on the hills and the flowers starting to come up. As you know I am crazy over fresh flowers, and I certainly miss them very much." [12]

A secretary in camp, Maurine Nelson, remem-

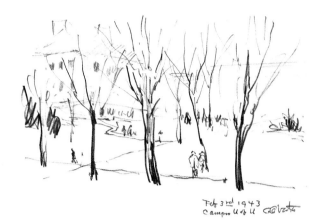

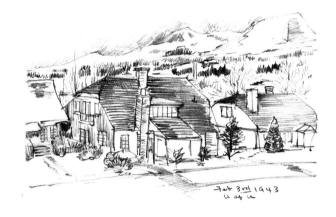

Sketches of the University of Utah
February 3, 1943
Pencil on paper, 5 x 7 in.

bered how "Madam Obata would gather up sticks, rocks, sagebrush, and everything she could find out in the desert and . . . made the prettiest arrangements you have ever seen."[13] Haruko also went to Delta to give an ikebana demonstration. She recalled:

> *The Delta undertaker came many times to camp to take care of the funerals. He was very kind to me. Once he came to help me gather flowers and also drove me to Delta for my demonstration. He invited me to lunch at his home. He helped me gather many flowers and branches, so much that I filled up his big van. He said it was the first time he had only flowers in his hearse; usually he had a body in the back. I said, "Before I die I get to ride in a hearse."*

While at Topaz, Obata conducted many painting demonstrations for church organiza-

tions, classes, or camp visitors. It was a feature of his demonstrations to ask a volunteer from the audience to paint a mark, which Obata would then transform into a painting. One Utah guest painted a red square in the center of the white paper, and after some thought, Obata painted a sunset landscape of the desert mountains. He completed the picture by painting barbed wire connected to the red square: one of the red-framed regulation signs posted on the fence surrounding the camp.

The Obatas were allowed two overnight excursions in the spring of 1943 to give lectures and demonstrations in the surrounding towns. They particularly enjoyed a busy lecture schedule at Brigham Young University and the University of

Utah, where they lunched with faculty members and later with the Literary Club of Utah.

> The students were very attentive and seemed to have enjoyed our demonstrations as I believe it was the first time for many of them to see Japanese Freehand Brush work and flower arrangement. We both enjoyed our trip to the city after being in camp for nearly a year.[14]

After giving a demonstration in the nearby town of Oak City, the Obatas stayed overnight at the home of Mr. Anderson, one of the local residents. Obata wrote to Jack Boylin:

> They are living very peacefully. This man looks over 75 years old, but looks very healthy and lives in perfect coordination with the surrounding nature. They produce bacon, ham, butter, milk, vegetable, and wood themselves. It seems as though this locality is not affected by war. I really enjoyed seeing such family living naturally with nature. I am collecting many sketches of just these things and sometime if you want to arrange an exhibit of my work, let me know and I will send them to you. It is very interesting to see the condition of living of these people—very simple and refreshing in contrast to city life.[15]

In May 1943, the "Relocation Center Art Exhibit," sponsored by the Friends Center in Cambridge, Massachusetts, awarded first prize to "New Moon" by Obata. Two other Topaz Art School instructors also received awards: Hisako Hibi for best flower painting and Frank Taira for best portrait. "Entries, many by Japanese American artists with established reputations, poured in from all ten evacuation camps. They revealed the bleakness, the sense of being apart and uprooted, but often, too, they discovered a certain beauty in the very austerity of the surroundings."[16]

Also in May, a delegation of Japanese American Citizens League representatives went to Washington, D.C., to present two commissioned Obata paintings, one to the WRA director, Dillon Myer, and the other to First Lady Eleanor Roosevelt. From the beginning, Eleanor Roosevelt had tried to influence public opinion toward fair treatment of the Nisei. "The day after Pearl Harbor she flew to Seattle, posed with four Nisei, pleading in the press that these loyal American citizens of Japanese descent be treated with neighborliness and the American sense of

THE WHITE HOUSE
WASHINGTON

June 16, 1943.

Dear Professor Obata:

Thank you so much for your
painting, "Moonlight over Topaz, Utah",
which was presented to me on behalf of
the Japanese American Citizens League.
It is very charming and I am delighted
to have it.

Very sincerely yours,

Eleanor Roosevelt

fair play."[17] This serene landscape painting, with Obata's subtle but telling inclusion of a fence and a guard tower, remained in Roosevelt's possession until her death [page 127].

The Obatas were concerned for their relatives in Japan, but correspondence to Japan was virtually impossible during the war except for an occasional twenty-five word maximum communication conducted through the International Red Cross. A note to Haruko's family read: "Second and third letter received. Thanks. We all well. Please be ease about us. Wish good health for you and all families in Fukuoka." They later learned

that the Obata family home in Sendai was miraculously untouched during a bombing raid, and the collection of Obata's father's paintings survived intact.

In March, Obata recorded the arrival of 230 internees sent to Topaz from Hawaii:

After 9:00 the first group of twenty-five to twenty-six people arrived in a truck as the Boy Scout band played its music in the wind. The people descending from the truck were about twenty to thirty-five years old, in their most productive years. I relate here the story I heard from one of the early arrivals: "Before we left Hawaii we were confined in an internment camp on an isolated island near Honolulu. . . . We are all Nisei, and we think the reason we were interned is because most of us had visited Japan and were educated in Japan—we are Kibei Nisei."

Farewell to parents, to brothers and sisters, to good friends with whom they can share their hardship, even to those loved ones who can comfort one another in misfortune. They spent more than a year in anxiety and darkness. For the second time they are sent on a journey by boat and train not knowing their destination. This step was taken in the name

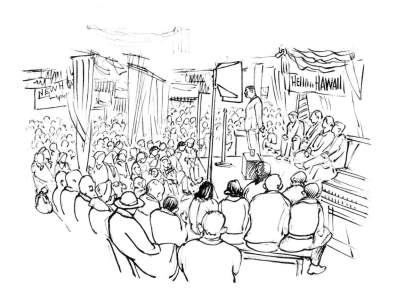

Welcome Hawaiians
Topaz
March 14, 1943
Pen and sumi on paper, 9 x 12 in.

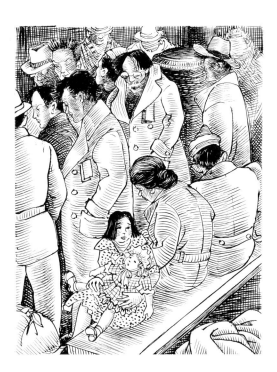

[Hawaiians]
1943
Pencil and ink, 9 x 7 in.

大体の荷物をいち
風呂敷につつまれた、僅
の若物を…

のやの

One Bundle Allowed Per Person
1943
Pencil and sumi on paper, 12 x 8¾

*It is hardly anything one could
call baggage; just a few trivial
things wrapped in a* furoshiki
(a wrapping cloth).

Our Toilet Congress
Where Rumors Come From
1943
Pencil and ink on paper, 4½ x 2 in.

of civilization for the evacuation. Some have a white and blue tag, some a red and white. Treated like a pig and cow, people call this modern organization. Dark face and pure black hair, they drag their only belongings in sacks made out of rice and flour sacks. Deep down we see their determination to accept this strange fate. Is this a step toward the construction of a great peace in the future? We can't say yes without tears. I hope our comrades have concrete steps to console the newcomers as much as possible.

The government's demand in early 1943 that the internees sign loyalty oaths created a dilemma of conscience and polarized emotions within the camps. By swearing loyalty to the United States, a country that denied them citizenship, the Issei would be renouncing their native Japan and become, in effect, people without a country. The pro-Japan agitators were largely made up of *Kibei* (born in the United States and educated in Japan) who focused their anger toward those whom they considered to be pro-administration. Haruko recalled the controversy in the camp:

Many people thought Papa was like a spy. The Kibei were so against America. One day the administration said everybody had to sign a paper: Are you going to obey America or obey Japan? So Papa, what can he do? He said he and I could go back to Japan, but the children will never go back. That's the way we decided. We chose our life in America. He put the mark, yes. The Kibei all put, no. In the camp when we heard about the war news, the Kibei would yell, "Banzai, Banzai," whenever Japan won a battle. Lots of cheers were given. Some people said if either side wins it will feel strange. They won't feel good if Japan loses. They don't want America to lose either.

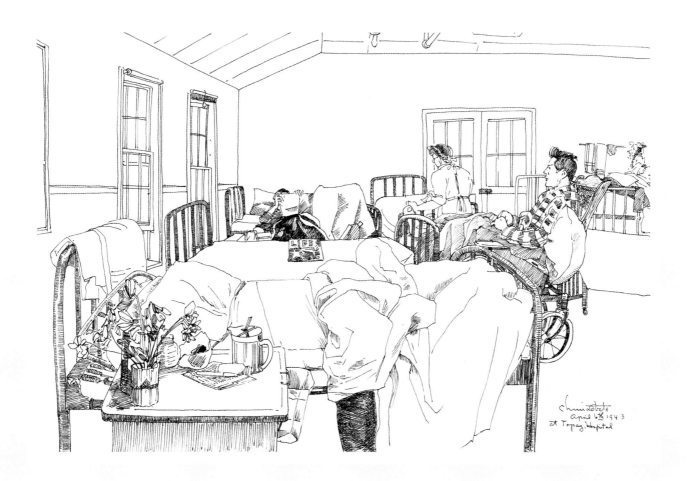

At Topaz Hospital
April 6, 1943
Pen on paper, 11¾ x 17¾ in.

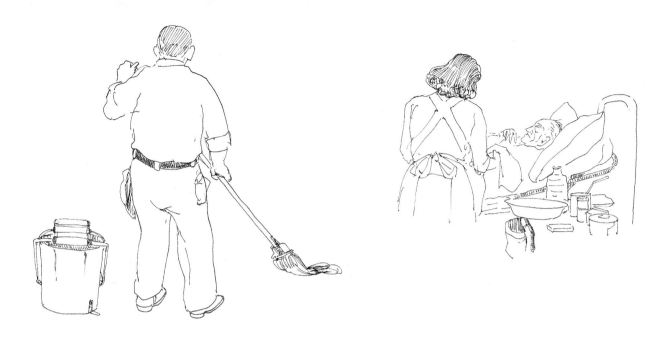

[Untitled, Topaz Hospital]
1943
Pen on paper, 12 x 18 in.

Late at night on April 4, Obata stepped out of the shower room to begin the walk back to his barrack when an assailant struck him with a blow to his face. After telling Haruko what had happened, he then walked to the hospital, still dressed in his bloodstained robe. The attack brought about the end of Obata's life as an internee. After nineteen days in the Topaz hospital, Obata was released permanently from the camps to insure his safety. He wrote to Eleanor Breed:

Why I was attacked, I myself do not know. In this Relocation Center, the general colorless scenery— the whitish gray of the barracks, no green vegetation growing—can cause even a person in a splendid state of mind to weaken to rumors, which are constantly present. It seems one implied that I was connected with the FBI. In any case, this abnormal state of life can contribute to such dreadful acts. I feel sorry for the attacker, who has not yet been identified, for his attempt to kill or hurt me will not better his life.

My wound was made by a blow struck with a blunt metal instrument on my forehead over the left

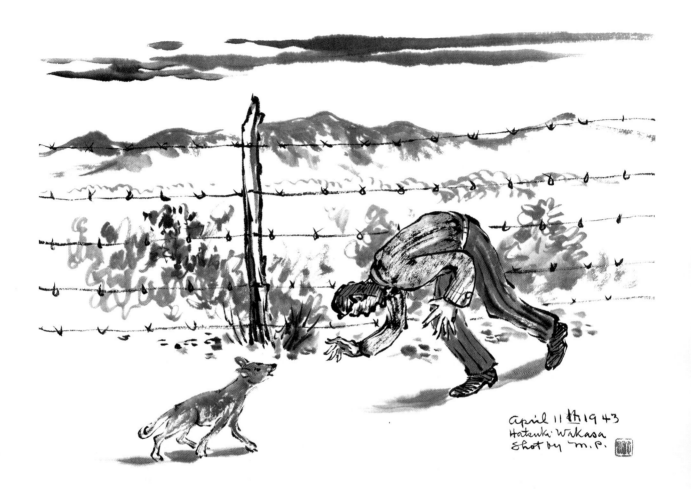

Hatsuki Wakasa, Shot by M.P.
April 11, 1943
Sumi on paper, 11 x 15¾ in.

Topaz Art School, ca 1944.
Seated in the front row from right to left:
Hisako Hibi, Ibuki Hibi, Midori Hanamura,
Matsusaburo Hibi, Masako Yamamoto,[18]
and two unknown women.

[After Chiura Obata's departure in 1943,
the Topaz Art School continued for two
more years under the leadership of
Matsusaburo Hibi.]

*eye. There were ten stitches taken. Although the
wound is healing, I still do not have any sense of
feeling around it, so I am taking things easy. You
know that this is my first experience of not doing
anything, as I have never been sick. So when I first
came into the hospital, I began writing letters and
sketching, but the doctors have refused to let me do
anymore.*[19]

While Obata was recuperating in the Topaz
Hospital, an internee named Hatsuki Wakasa was
walking near the fenced perimeter when he was
shot and killed by a guard. Obata recorded the
incident as related by the residents: Wakasa was
with his dog at the fence and was unable to hear
the military sentry's verbal warning. This was one
of the last images Obata would paint of Topaz.
On April 23 he was released to Salt Lake City for
further medical treatment; several weeks later,
Haruko and Yuri were also permanently released
from the camp.

Relocation

You must always see with a big vision, and
if you keep your mind calm there will be a way,
there will be a light.
CHIURA OBATA, 1965

During the summer of 1943, many internees
began to relocate to Midwestern and Eastern
cities. In early spring of that year, Obata had filed
the five required letters of recommendation to
leave camp. But as of April, he had not yet
planned to depart; instead, he submitted a pro-
posal to take students outside the camp for a
summer sketching course. When he was released
from Topaz following the attack, he suddenly had
to find a home in the outside world and became
acutely aware of the difficulties for an Issei to
support his family. He was resigned, if necessary,
to find farm work as had many other evacuees.
Obata first stayed with Nisei friends in Salt Lake

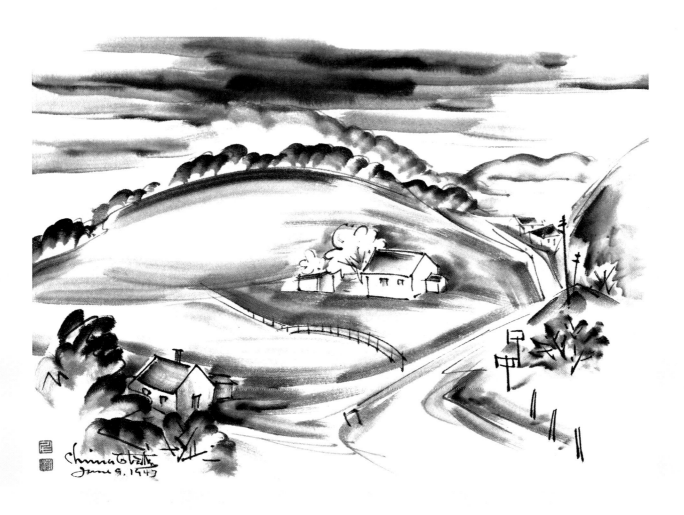

June 9, 1943
Sumi on paper, 9 x 13 in.

Chiura Obata working at the Advertiser's Display and Exhibit, Inc., St. Louis. WRA photograph by Hikaru Iwasaki, 1944.

City, and then went to Chicago, staying at the American Friends Hostel while seeking job possibilities. Obata and his friends in California searched in vain for a college teaching position, but the war crisis had curtailed any funding for art courses.

In May, Obata went to St. Louis to visit his son Gyo. Eventually, Obata, Haruko, and Yuri settled in Webster Groves, a suburb of St. Louis, where they met a helpful and sympathetic community [page 131]. The Obata family found themselves living for the first time, as did many relocated Japanese Americans, without Japanese neighbors in their community.

Both Chiura and Haruko found work at a commercial art company in downtown St. Louis; Obata painted designs and sceneries with his freehand brush techniques, and Haruko worked making artificial flowers. Kim Obata also left Topaz for St. Louis and took a position in the same company as an art designer. In 1943 Kim wrote the following letter to Ruth Kingman:

I'm now working for a commercial art company, Advertiser's Display and Exhibit Inc. It's lots of fun and

*lots of work for it seems that this company [is]
one of the few large firms left to handle the work
in St. Louis.*

*You know—I'm still kind of leery of people
and things, for nothing is exactly the same. There
is always the feeling of unpredictable that-might-
happen-again and we-don't-want-to-be-caught-
short-again. Once burnt—. But, all this happens
with a little more value, a little more thankfulness
that we are in America. . . .*

*If anything, I find everything just wonderful, I
had to fight for my democracy, it's mine, I wasn't
just born with it—to be taken for granted—I think
I proved my worth, dependability, and my trust by
taking all the heartaches and disillusions—and still
believe in America.*

*With this war [people's] cherished beliefs in
the eternal sameness of things were completely
demolished. Now I believe that the only way to
solve this problem is to be really intent on life. We
have to be excited, so bent on living that life will
seem necessary and important. We can't be an insti-
tutional sort of an animal anymore. I guess we have
to take adventurous flights in pursuits of the sun,*

*and our capacity to enjoy life will be measured by
our own ability to create a life or beauty or some
sort of happiness.*

Still pitching, Kim[1]

Commuting by trolley, working a full week at
the office painting window displays, and attend-
ing church on the weekends left Obata with little
time to paint. The war also made it difficult to
obtain the correct brushes and papers for sumi
painting. Yet while living in St. Louis, he gave
several painting demonstrations at churches and
clubs. Meanwhile, the Obata friends in California
continued to send letters of support and encour-
agement:

*It surely is terrible what you people have been forced
to go thru [sic]—and I feel certain that it was all
unnecessary—really just the result of hasty and ill-
informed public opinion. But at least it helps to hear
some of the officials saying that they admit it was a
mistake and undesirable from every standpoint.*

*Anyway we surely do miss you folks and hope it
won't be long before we can get together again.*

Jack Boylin
June 12, 1943[2]

Dear Mr. and Mrs. Obata,

You don't know me, but I have been wanting for a long time to tell you how I miss you here in Oakland. I teach at the McKinley School on Dwight Way, and I used to see your wonderful flower shows each year. . . .

Tho [sic] many of my friends have taken Mrs. Obata's course in flower arrangement, I never got around to it. But you may be sure when she opens her first class here again, I shall be the first to enroll. For we hope you'll both be back soon, for we need you in our community.

 Helen A. Burton

 May 2, 1943[3]

In 1944 there was still tremendous pressure to permanently exclude the Japanese Americans from the West Coast. Even California Governor Earl Warren initially opposed the evacuees' return. But public opinion about the exclusion was turning with reports of the heroic Japanese American combat teams (the 100th and 442nd battalions) fighting in Europe. The Fair Play Committee was finally gaining support for their cause. Robert Sproul spoke before the California Club in Los Angeles on June 29, 1944:

First and foremost, above everything else and for all of the time, the concern of the Committee on American Principles and Fair Play is for the integrity of the Bill of Rights of the Constitution of the United States. It believes with fervor, with fanaticism if you will, that whenever and wherever the constitutional guarantees are violated in the treatment of a minority, no matter how unpopular or helpless, the whole fabric of American government is weakened, its whole effectiveness impaired. Each such violation establishes an evil precedent which is inevitably turned against another minority later and eventually the very principle on which our Nation is founded, namely, the dignity and worth of the human individual.[4]

In January 1945, the military exclusion order was finally lifted. Obata immediately wrote to Monroe Deutsch asking to be reinstated at the university. During the entire period of his internment and relocation, Obata had corresponded with the University of California. His status as professor on indefinite leave of absence was

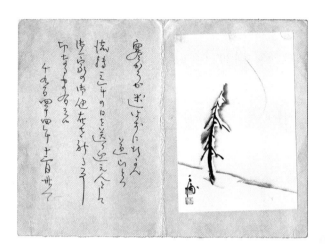

New Year's Card to the Hibi Family in Topaz
December 31, 1944
Sumi on paper, 6¼ x 4¼ in.
Hibi family papers

Even though it is so cold one can keep going without hesitation.
Next year will be the third year, and I pray for your family's health.
CHIURA OBATA

maintained for three years; the university had given him two-thirds pay on a sabbatical leave for the first six months after his departure. In this letter, he did not disguise his anxious hope that he would be able to return to Berkeley, to the friends and the natural surroundings of California, which he felt were most important to his life:

> We thank you deeply for your higher aim and tireless effort for humanity that brought the lifting of the blanket exclusion orders by the Western Defense Command for the Japanese American loyal citizens and law-abiding aliens.
>
> Gyo is enjoying school work and doing fine; he received last spring one of the highest scholarship undergraduate at the school of architecture. . . . Lillian [Yuri], the youngest girl in our family, will graduate Webster High School in the coming June, and she wishes to study art at the University of California. Kimio tried to get into the Army [while] at Topaz camp and after coming out here he was rejected on account of his bad left shoulder. . . . Masa works as a secretary at the Girl Scout office.
>
> It is my desire, also Mrs. Obata's, ever since we evacuated from Berkeley on April 30, 1942, we have kept in our minds returning to Berkeley, so that many times before I asked you to extend my indefinite leave of absence. I spent my most important age in California ever since I arrived from Japan to America, so I naturally owe endless things to nature, to Mother Earth in the state of California, and to all our friends who treated me with a kind heart during such long years. Therefore, we never changed our attitude, even feeling a hardship that hit us like the evacuation. After such an unnatural and costly evacuation movement I believe that in the future it may help us to build a much better basic idea for greater peace.[5]

In January 1945, the following letter from

Gyo, Yuri, Haruko and Chiura Obata,
Webster Groves, Missouri.
WRA photograph by Hikaru Iwasaki, 1944.

President Sproul confirmed Obata's reappointment:

> Professor Pepper informs me that your services will be needed with the beginning of the next academic year. . . . It gives me great pleasure to read in your letter to Dr. Deutsch that you are in the best of health, with eyesight unimpaired, and that you are busily at work, even though the tasks to which you have set your hand are not that which you would have freely chosen.[6]

After making arrangements to resume teaching for the fall semester, Chiura, Haruko, and Yuri once again packed their belongings, left their house in Webster Groves to Kim and Masa, and returned by train to California in early October. Just before their departure, they received a letter from Rev. Galen Fisher, who had worked during the war to dispel the racism against Japanese Americans:

> We are certainly glad to hear of your imminent return home. You can count on a warm welcome from your many friends both on campus and around town. The Golden Gate will stand open wide in symbolic welcome, and the Berkeley hills will clap their hands for joy."[7]

Return Home

*Everyone suffered a loss. What we had built
up during that long period—more than a half a
century or even a century—we had to leave and
abandon. . . . It goes without saying, this kind of
artificial relocation can have no benefit to people or
society or politics. . . . In short, the biggest difficulty
was not being able to work fully toward our hopes
and expectations. Other than that, anything physi-
cal or the desert storms—those things were second-
ary. The biggest hardship was when we wanted to
do something, we couldn't let our ability grow,
and we couldn't contribute to society.*

CHIURA OBATA, 1965

With the end of the war, Japanese Americans had
to decide whether to return to their hometowns
on the West Coast or to relocate to another part
of the United States. The reception of the Japan-
ese Americans returning to California was mixed;
some communities let it be clearly known that
Japanese were not welcome.

For the Obata family, 1945 would bring
a permanent split to their family: neither son
would return to live in California. Educational
and career opportunities for Gyo and Kim were
secure in the Midwest, and they would both
make St. Louis their home. Chiura, Haruko,
and Yuri returned to Berkeley in the unusual

position of having secure employment and a place to live. H. L. Dungan and his wife, Edda, opened up the top floor of their Berkeley home for the Obata family. "Your bedroom is furnished with two single beds, bedding, etc., so all you will have to do is to turn down the covers and hop in. . . . There is a welcome sign on the door for the Obatas."[1]

Uncertain about his reception by students at the university, Obata dropped the word "Japanese" from his sumi painting course description. But once in Berkeley, the overall climate was tolerant of the returning Japanese Americans. The Berkeley Interracial Community helped many returnees locate housing, and church groups organized temporary hostels.

After a few months, one of Obata's students helped the family find a studio apartment near campus. It was an adequate but small home; Yuri slept on the couch while her parents pulled a Murphy bed out of the dining room wall every night. They lived there for several years until they purchased a home with a garden.

Topaz officially closed in October 1945. Upon the evacuees' return to California, the Obatas enjoyed reunions with their friends, including journalist Shichinosuke Asano. Asano's decision to remain at Topaz for the duration of the war reflected the uncertainty most Issei had about life on the outside. In early 1945, in spite of the WRA's resettlement program, almost 6,000 people still remained in Topaz from a peak population of 9,438. Asano rebuilt his life in San Francisco working as the editor of a local Japanese newspaper. A leader in the community, he and his wife remained close friends of the Obatas.

The Hibi family also stayed in Topaz until the war ended. To commemorate the last exhibition of the Topaz Art School in June 1945, Matsusaburo Hibi stated, "Let us art lovers keep on . . . in the study of art, tirelessly wherever we shall relocate or whatever fate shall face us."[2] The Hibi family had neither a home nor a job in California. They decided to live first in New York City, where Hibi hoped to participate in the New York art scene. But just two years later Hibi died of cancer, leaving Hisako alone to support her two children by working as a dress-

Beth Blake and Kane Obata
(Chiura's stepmother) at the Obata
home, Sendai, Japan, 1946.

maker. Obata kept a painting of Topaz by Hibi for the remainder of his life. *Block #9, Topaz* [page 132] was displayed in Obata's studio in tribute to his friend and of the remarkable experiences they had faced together.

The Obata relatives in Japan had survived the war, but the American occupation made it difficult for the Obatas to communicate with or help their family during the first years after the war. Luckily, in 1946, former student Beth Blake happened to be one of the first military wives allowed to live in Japan. After visiting the Obata relatives in Tokyo and Sendai, she sent the first letters and photos back to Berkeley assuring the Obatas of their family's well being.

In January 1946, three months after his return to Berkeley, 100 of Obata's sketches and paintings of the internment camps were exhibited at the College of the Pacific in Stockton. A local newspaper reported, "According to Professor Obata [the exhibition] has a twofold mission—to express his appreciation of the beauty of nature on one hand and of man's struggle toward higher human values on the other."[3] In June of that same year, eighty representative pieces were exhibited at the University of California's Haviland Hall. Included in this exhibit were Obata's expressionistic images of the atomic bombing of Hiroshima [pages 134–36].

After the UC Berkeley show, there was little interest in the camp paintings. Obata, however, realized the importance of this collection. Together with the many letters and documents he had saved from the internment camps, he managed to store the series largely intact.

Obata taught at the university for nine more

Chiura Obata at an exhibition of his camp paintings, Haviland Hall, UC Berkeley, 1946.

years after his return to Berkeley, and Haruko continued to teach ikebana. They had a busy social life with their many acquaintances, including new friendships with students. Chiura enjoyed taking his painting students for sketching tours to the local beaches, where he would conveniently find time to go surf fishing. He joined the Sierra Club and went on their group camping trips into the mountains, delighting fellow campers with a painting demonstration by the campfire. Obata also returned to paint his favorite beauty spots, Yosemite and Point Lobos, as well as many other scenic locations in California, and traveled to the Southwest and New England on sabbaticals from the university.

The Obatas stayed in close contact with their daughter, Yuri, who had married her childhood friend, Eugene Kodani, and lived in nearby Oakland. While she and Eugene raised their three children—Mia, Kei, and me—they also assisted Chiura and Haruko in all aspects of their lives from business to social occasions. Family gatherings with the grandchildren were a Sunday ritual, highlighted by a dinner of fresh fish caught by Obata that morning. As the Obatas aged, Yuri and her family took on the responsibilities of caregivers. The family provided care and support for both Chiura and Haruko until their deaths.

Kim founded a partnership in St. Louis called Obata Design. One of his most recogniz-

Haruko and Chiura Obata, Kintai Bridge, Iwakuni, Japan, ca 1960.

able designs from the early years was the Bavarian Busch beer label for the Anhauser Busch Company. In 1965 Kim and Masa divorced, and Kim began a new career in Japan. With the help of his second wife, Tomoko, he became fluent in Japanese and ran a successful firm, Obata Design, in Tokyo. Kim helped develop business relations between various American and Japanese companies until his death in Tokyo in 1986.

Gyo attended graduate school on scholarship at the Cranbrook Academy of Art in Michigan and began his architectural career working in Chicago and Detroit. In 1955 he became a partner and principal in charge of design in the Hellmuth, Obata & Kassabaum (HOK) architectural firm in St. Louis. Under his design leadership, HOK grew from a small office to one of the largest architectural and engineering firms in the world today.[4]

In 1952 the immigration laws were revised and Asians were granted permission to apply for American citizenship. Both Chiura and Haruko attended citizenship classes in Berkeley and became naturalized in 1954.

After retiring as Professor Emeritus from the university in 1954, Obata began a new career leading tours to Japan every spring and autumn. For fifteen years, until he was eighty-four years

Chiura Obata with his painting,
Glorious Struggle, 1965.

received the Emperor's Medal for her lifetime devotion to the teaching of ikebana. The Obatas became the first husband and wife residing in the United States to be individually honored for their efforts in bringing Japanese cultural arts to America.

In 1972 the California Historical Society sponsored a group exhibition, called "Months of Waiting," on the art of the internment camps, which included a selection of Obata paintings. The positive response to this show was important in bringing back to light an injustice that had been hidden for many years. Obata passed away three years later at age ninety, and he was not able to witness the renewed interest in his work from the *Sansei* (third-generation Japanese American) students at the local universities, who consistently represented his work in anthologies and exhibits about the camp experience. It had indeed been Obata's hope that his pictorial record would serve to further an awareness and understanding of the events of the evacuation.

old, he and Haruko introduced many Americans to the aesthetics of Japanese arts, gardens, and architecture. "The purpose of the trip," he said, "is to achieve better understanding. I'm doing this in the hope that the two countries can talk fully, and if there is something like a war, they can find some way to find agreement, and won't do that kind of unnecessary thing if they can communicate on a better level."

In 1965 Obata was awarded the prestigious Emperor's Medal in Tokyo for his contributions in promoting understanding between Japan and the United States, and in 1976 Haruko also

Glorious Struggle
1965
Sumi on silk, 36 x 22 in.
Department of Special Collections,
Charles E. Young Research Library, UCLA

*Since I came to the United States in 1903,
I saw, faced, and heard many struggles
among our Japanese Issei. The sudden
burst of Pearl Harbor was as if the mother
earth on which we stood was swept by
the terrific force of a big wave of resent-
ment of the American people. Our dignity
and our hopes were crushed. In such
times I heard the gentle but strong whis-
per of the Sequoia gigantea: "Hear me,
you poor man. I've stood here more than
three thousand and seven hundred years
in rain, snow, storm, and even mountain
fire still keeping my thankful attitude
strongly with nature — do not cry, do not
spend your time and energy worrying.
You have children following. Keep up
your unity; come with me." So, in the
past, all such troubles moved like a cool
fog. In deep respect I present my painting
to our Nisei and the future generation.*
CHIURA OBATA, 1965

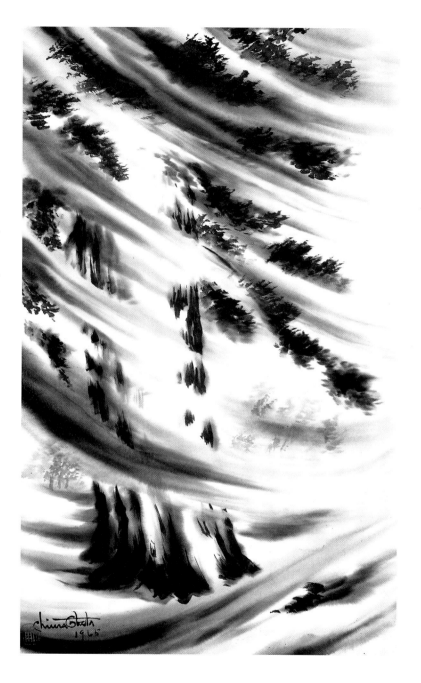

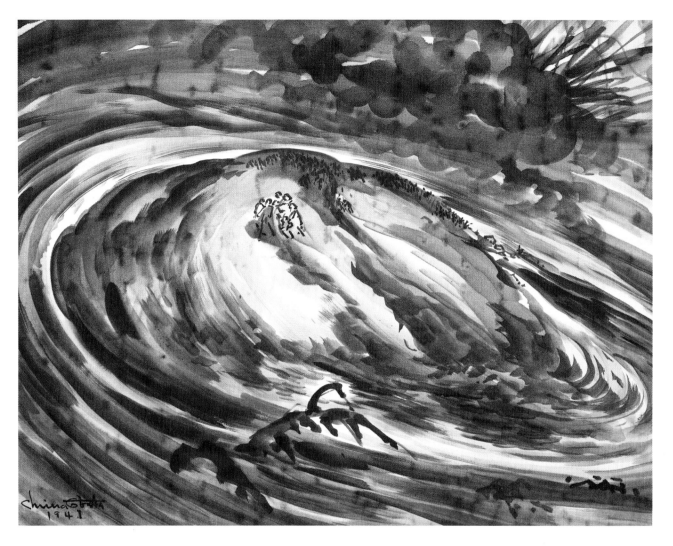

To the Japanese artist, the morning of Pearl Harbor came as a landslide, implacable and overwhelming. Once he had seen a spring freshet envelop a small wooded knoll, water soaked with winter rains, tugging at it with insistent pressure until the whole mass slipped into the muddy torrent. Thus, on the morning of December seventh, the artist saw himself and his family, each with his own sense of sudden loss, huddled together while the vortex of war swirled their foundations away beneath them.

EXHIBITION TEXT, 1946

Landslide
1941
Sumi and watercolor on paper, 22 x 28 in.

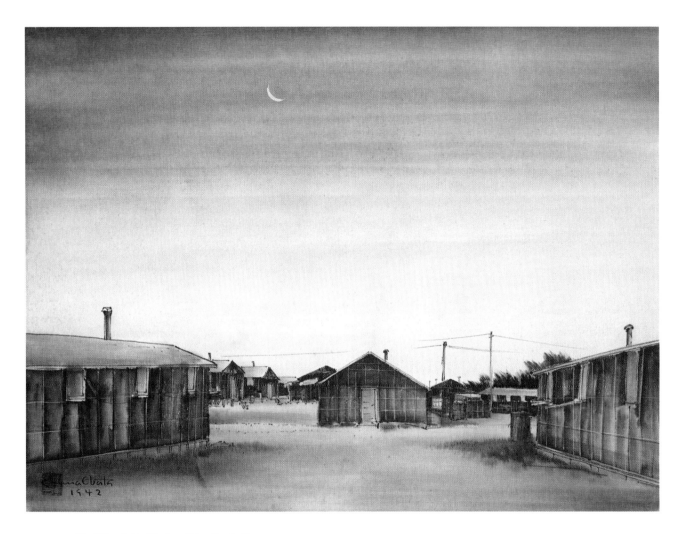

Silent Moonlight at Tanforan Relocation Center
1942
Watercolor on paper, 15¼ x 20½ in.

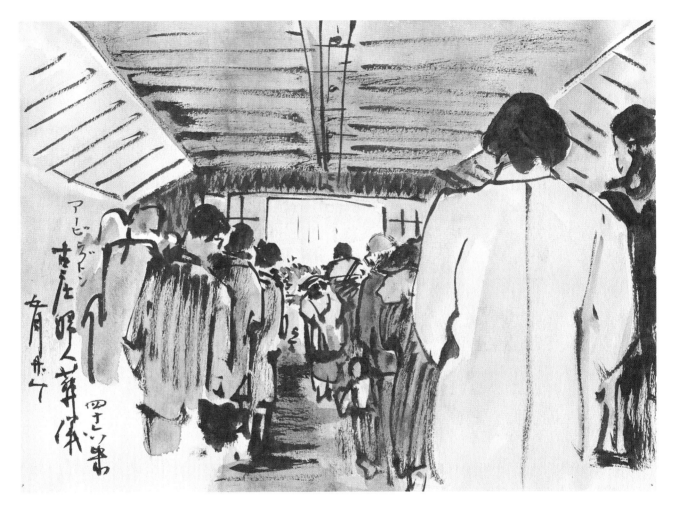

First Funeral at Tanforan
May 28, 1942
Sumi and watercolor on paper, 9 x 12 in.

Mrs. Furushio from Irvington, forty-six years old.

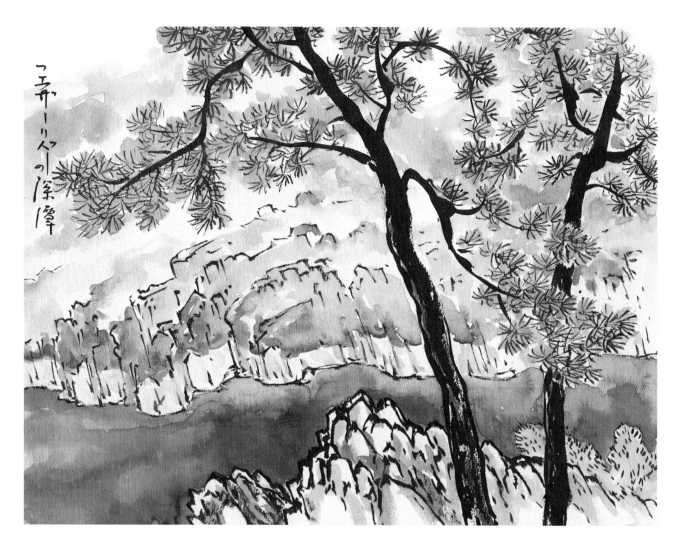

Feather River Canyon
1942
Watercolor on paper, 9 x 12 in.

Good-bye, California! Good-bye to our beloved mother state. Our last adieus were said as we sped past the beautiful Feather River.
CHIURA OBATA, 1942

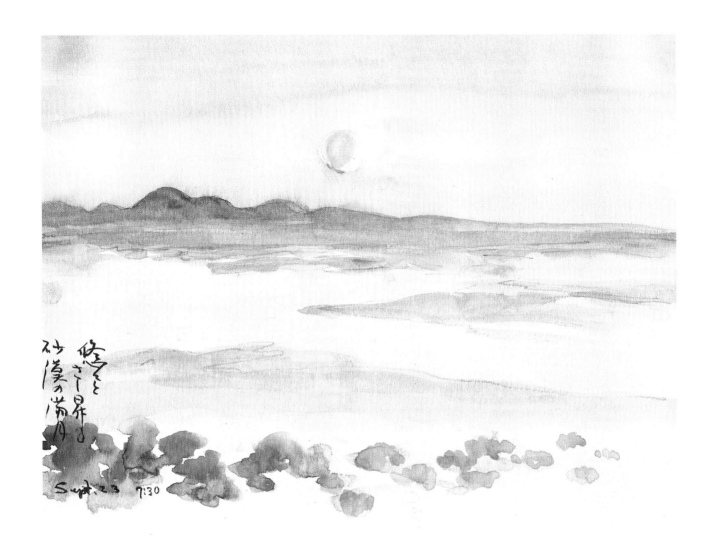

Sept. 23, 7:30
1942
Watercolor on paper, 9 x 12 in.

Rising eternal in the desert — the full moon

: 117

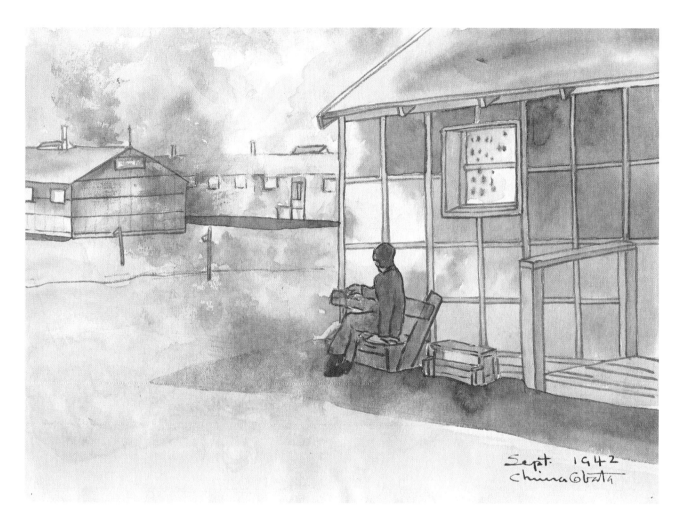

Sept. 1942
Topaz
Watercolor on paper, 9 x 12 in.

Arrived Thursday, September 24, about 2 p.m., and found the place still
under construction. The climate was very hot—110 degrees. The dust
raised by the wind and passing trucks is like a smoke screen.
LETTER FROM CHIURA OBATA TO DOROTHEA LANGE, SEPTEMBER 29, 1942[1]

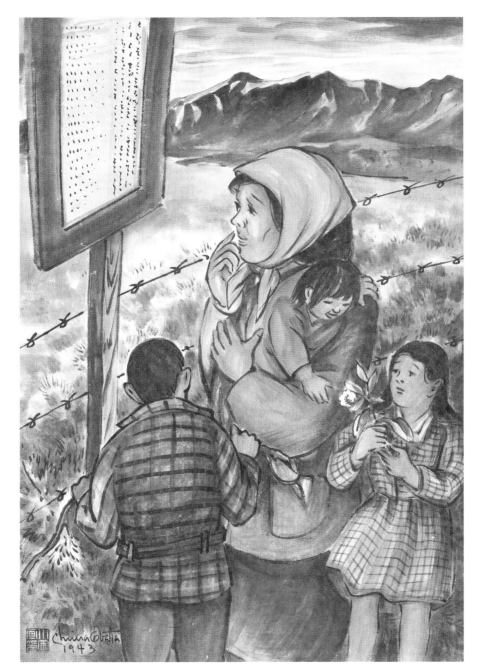

Regulations
1943
Watercolor on paper, 18 x 12½ in.

Dust Storm

ca 1943

Watercolor on paper, 13 x 18¼ in.

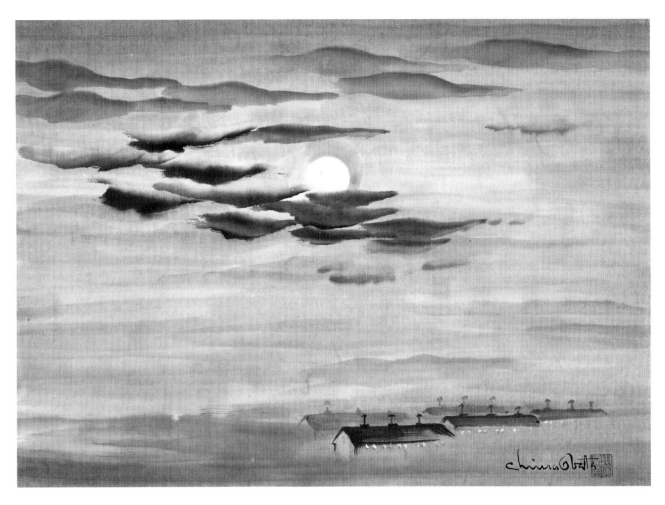

Topaz War Relocation Center by Moonlight
ca 1943
Watercolor on paper, 14¼ x 19¼ in.

Season's Greetings from Topaz
1943
Linoleum print and watercolor on paper, 3¾ x 5¾ in.
Gift of Elizabeth Y. Yamada, Japanese American National Museum (93.75.1)

Even in camp we were able to enjoy the holidays. Everyone pitched in with
grim determination to help express the meaning of a real Christmas.
LETTER FROM HARUKO OBATA TO EDITH HILLER, 1942

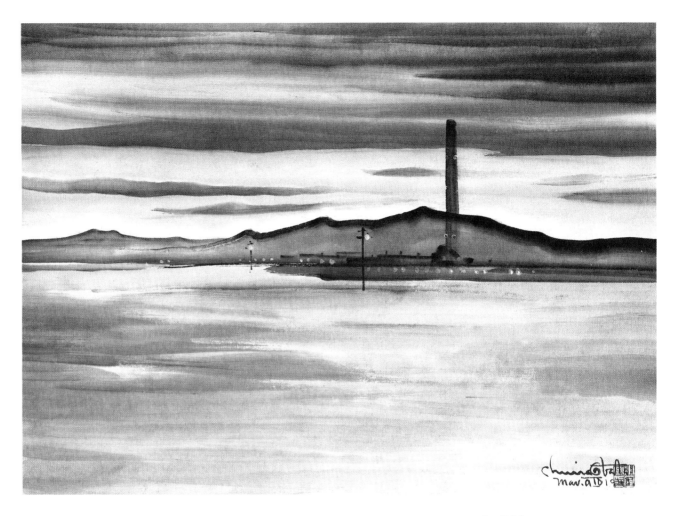

Hospital, Topaz
March 10, 1943
Watercolor on paper, 14½ x 19 in.

Topaz Mountains
ca 1943
Watercolor on silk, 15¼ x 19¼ in.

Training in art maintains high ideals among our people, for its object
is to prevent their minds from remaining on the plains, to encourage
human spirits to dwell high above the mountains.
MATSUSABURO HIBI, TOPAZ ART SCHOOL, 1943

Topaz Relocation Center, Utah
June 1943
Watercolor and airbrush on paper, 14¾ x 22½ in.

Near Topaz, Utah
ca 1943
Watercolor on paper, 13½ x 18½ in.

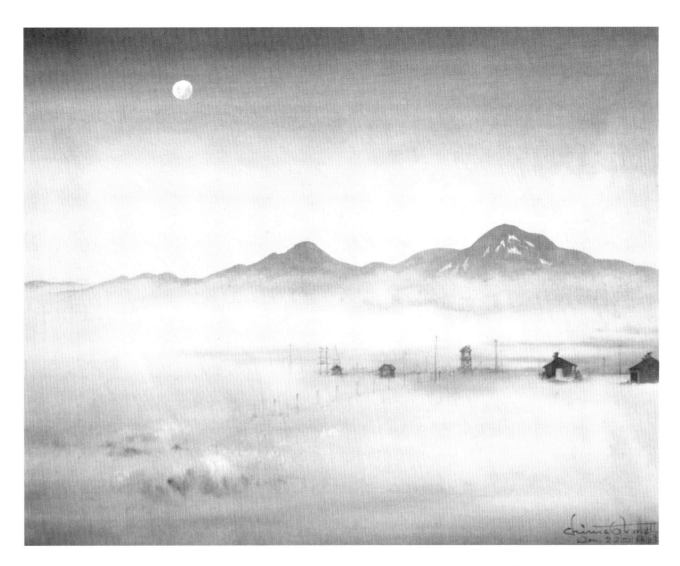

Moonlight Over Topaz
December 22, 1942
Watercolor on silk, 15¾ x 20 in.
Franklin D. Roosevelt Library

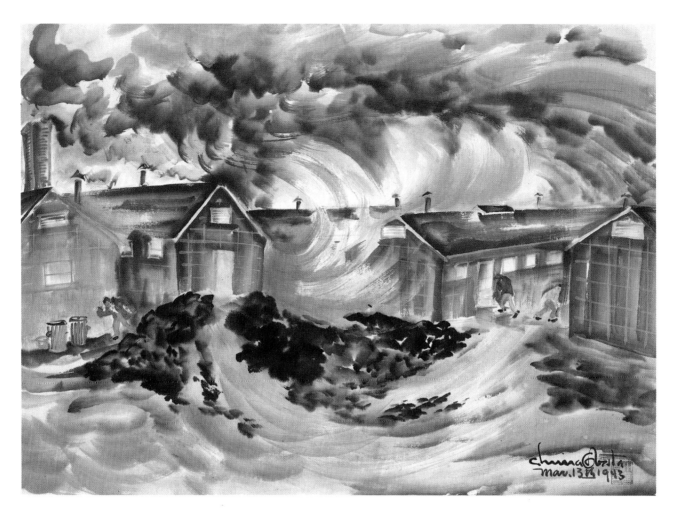

Dust Storm, Topaz

March 13, 1943

Watercolor on paper, 14¼ x 19¼ in.

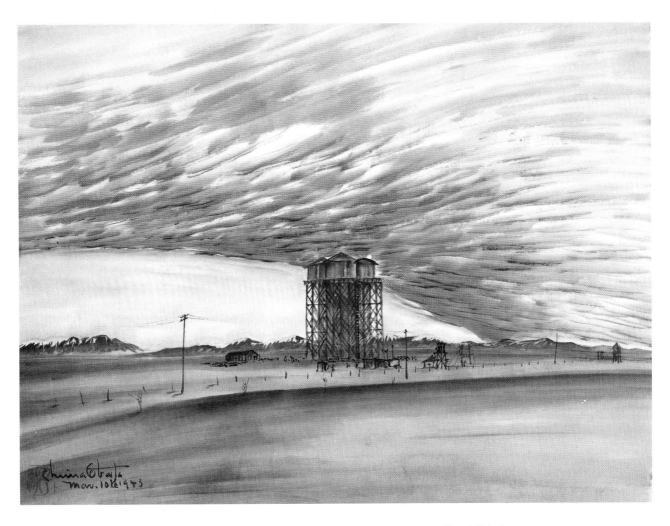

The dining room was only open from six to seven. One night we went out a little before six, the sunset was so beautiful Papa wanted to paint. I said to him, "You have to go otherwise we're going to miss dinner," but he wouldn't stop. So I just left him, and I had to hurry to get two plates filled then hurry back to help him with the colors. It was really beautiful that time.
HARUKO OBATA, 1986

Sunset, Water Tower
Topaz
March 10, 1943
Watercolor on paper, 15½ x 20½ in.

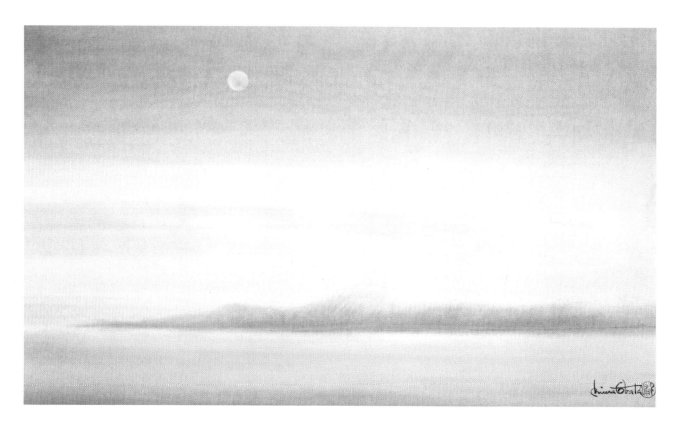

East Moon, Sevier Desert, Utah
1943
Watercolor on silk, 20 x 33½ in.
Private collection

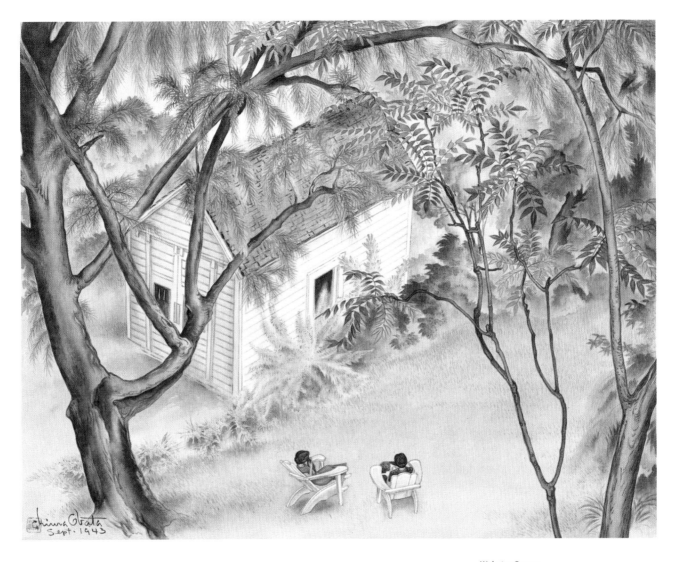

Webster Groves
September 19, 1943
Watercolor on silk, 15 1/2 x 20 in.
Private collection

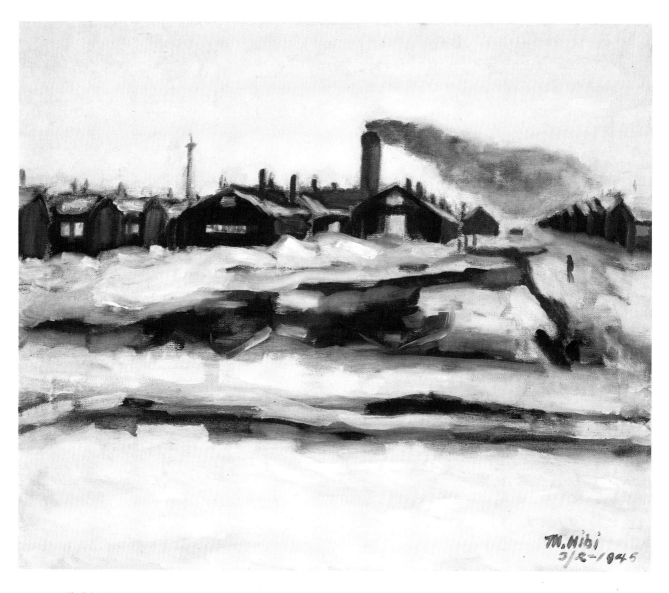

Block #9, Topaz
March 2, 1945
Matsusaburo (George) Hibi
Oil on canvas, 22 x 26 in.
Fine Arts Museums of San Francisco, gift of Ibuki Hibi Lee. 1997.2.1

I am now inside of barbed wires but still sticking in Art —
I seek no dirt of the earth — but the light in the star of the sky.[2]
MATSUSABURO HIBI, DECEMBER 9, 1944

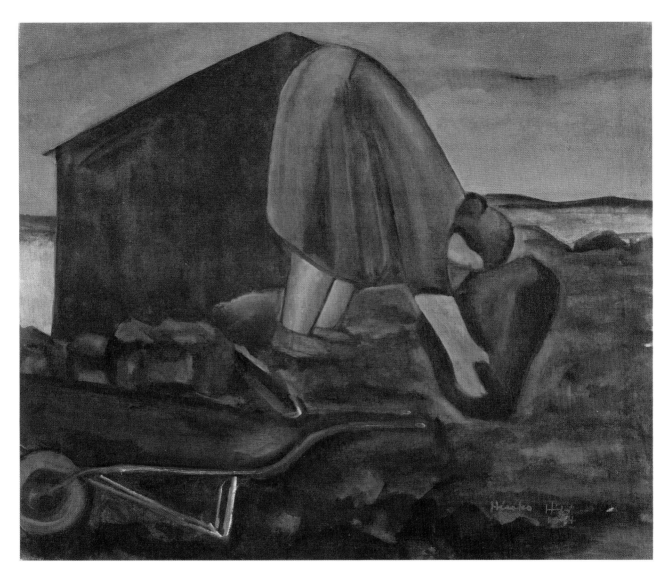

[In those kinds] of conditions, what can you do? You think in
a negative way—it won't help—we cannot get away. . . . We did
think in an educational way and in a much more positive way
we spent our days. . . . They said, like Paul Klee, . . . "Look at life
from just a different angle. You'll see a different perspective."[3]
HISAKO HIBI, 1986

Fetch Coal for the Pot-belly Stove, Topaz, Utah
December 1944
Hisako Hibi
Oil on canvas 20 x 24 in.
Fine Arts Museums of San Francisco, gift of Ibuki Hibi Lee. 1997.2.2

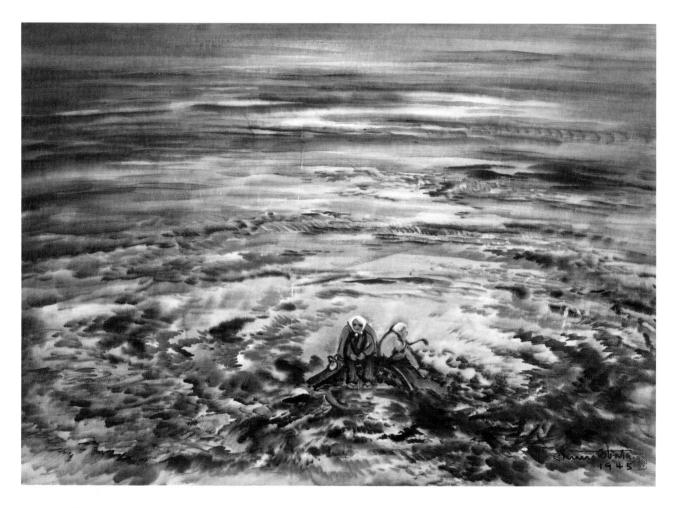

Devastation

1945

Watercolor on paper, 13 x 18½ in.

When the first atomic bomb fell on Hiroshima, man unloosed forces he did not understand. People said that the devastation was complete, that never again could the Japanese city support life, that a small portion of the world, in effect, had ceased to be. Chiura Obata could not accept this thought. He believes that the forces of nature, the powers of good and of life, will surely overcome any man-made destruction. On the day after the first blast he conceived a trio of paintings, which would depict what he knew to be truth, the triumph of nature. This, the first of the three paintings, tries to show a measure of the devastation, apparently utter and complete. But already there is life in the scene; two humans have survived, or have returned to the scene of the holocaust.
EXHIBITION TEXT, 1946

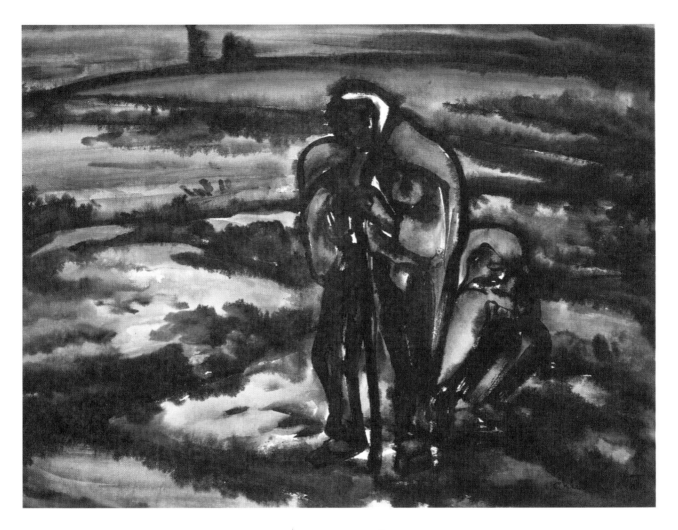

Prayer
1946
Watercolor on paper, 21 x 28 in.

*In this second painting Chiura Obata reiterates his
theme of utter devastation. It might be merely a close-up
of hopelessness, horror, and abject misery, except that it also
reflects courage, a will to survive, a growing determination to
remain, a hopeful prayer of fulfillment.*
EXHIBITION TEXT, 1946

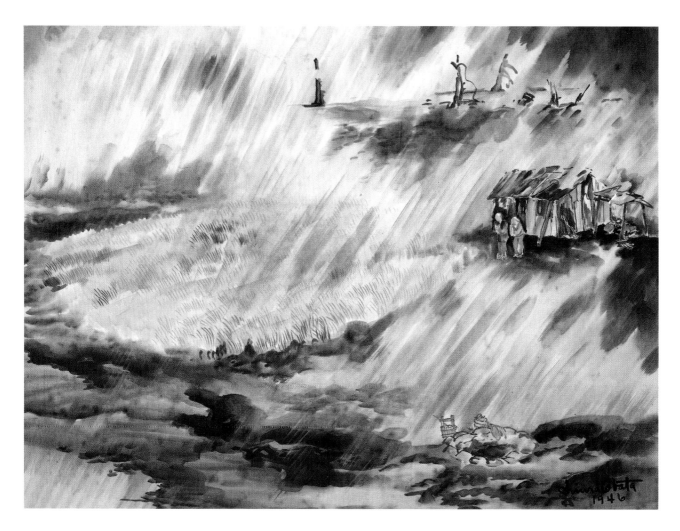

Harmony
1946
Watercolor on paper, 22 x 29 in.

Months later Chiura Obata read that amid the wreckage of Hiroshima spring
grass was growing, and his beliefs were vindicated. Nature was already absorbing
the scar tissue of war. The final painting of his Hiroshima trio and of his war series,
he calls "Harmony," because there is always harmony in nature, a balance between
the dead and the living, between destruction and resurgence.
EXHIBITION TEXT, 1946

Epilogue

The horizontal line connects freely right and left, east and west, north and south, and all other directions. Describing this line in form, it is the symbol of the periods that unite the present with the past and future.

CHIURA OBATA, 1967

In 1942 Topaz was the fifth most populous city in Utah. After the war, the site was deserted for fifty years. Only recently have preservationists been working to prevent development within the grounds of the original site.[1] Little remains on the Topaz site but portions of the barbed wire fence, some ruined foundations, and the scant evidence of pathways and gardens. Yet what continues to survive are documents, photographs, art, and the individual stories of the thousands of people who were interned or worked there. Every story is unique, and every story a part of the legacy of the internment in American history. This book has been the story of my family.

First Snow
October 29, 1942
Sumi on paper, 10¾ x 15¼ in.

In 1985 curatorial work began at the Smithsonian Institution's National Museum of American History for a permanent exhibit of the history of the Japanese American internment during World War II. Under the direction of Roger Kennedy, "A More Perfect Union: Japanese Americans and the Constitution" opened in 1987 as part of the Smithsonian's bicentennial celebration of the Constitution of the United States. Kennedy said, "This is about as unabashedly patriotic a display as you're going to see this year, maybe this decade. . . . The difference between American culture and most others is we have a long tradition of self-correction, a long tradition that I believe from the beginning distinguished us from tyrannical systems."[2]

The curator of the exhibit, Tom Crouch, asked for permission to display several reproductions of Obata's internment camp paintings together with explanatory text. This gave me the impetus to research my grandfather's life, and in particular, his experiences in the camps. At that time I was living with my grandmother, Haruko, and I was gradually assuming the role as her primary caregiver. Stored in boxes in her house were dozens and dozens of letters, Christmas cards, and documents dating from 1942 to 1943—all from Tanforan and Topaz. At age ninety-four, Haruko was quite willing to answer questions about her life

Untitled
April 20, 1943
Pen on paper, 18 x 12 in.

[While recuperating in the Topaz Hospital, Obata drew this still life of Haruko's flower arrangement and a book of poems, *Issa and Ryōkan and Bashō,* by Mifū Sōma.[3]]

in the camps as she had done many times before in reference to her husband's paintings. She said, "Some Issei don't want to talk about that time, but it happened to all of us so I'll talk about it. We didn't do anything wrong. If I had done something wrong I would be too ashamed to talk about it. But they [the government] did wrong, not I."

In November 1987, Haruko flew to Washington, D.C., to attend the exhibition's opening with her family members, including Gyo, Yuri, and me. Not only did she view the many reproductions of her husband's paintings in the Smithsonian Museum, but she also visited the Smithsonian Institution's Air and Space Museum, one of the most famous buildings designed by her son Gyo. Two years later, Haruko passed away at the age of ninety-seven.

Haruko had literally created thousands of flower arrangements during her long career as a teacher of ikebana. Her art was ephemeral, and not one of her arrangements survives today. But the lessons she taught are continued by a new generation who are admirers of the art of flowers.

And so we must hope that our memories of Topaz will survive, and the lessons learned will be everlasting.

Endnotes

INTRODUCTION

1. *Personal Justice Denied: Report of the Commission on Wartime Relocation and Internment of Civilians* (Seattle: University of Washington Press, © 1982, 1997 reprint), 135.

A CALIFORNIA ARTIST

1. "California Japanese," *Time* magazine, April 25, 1938.
2. "Chiura Obata." In *California Art Research,* First Series 120–160. (San Francisco: WPA Federal Art Project, 1937), 125.
3. Japonism: something characteristically Japanese.
4. Robert Sibley, ed. *The Seasons at California* (Berkeley: California Monthly, 1939).
5. *California Art Research,* 152.

LANDSLIDE

1. Robert T. Yamada, *The Berkeley Legacy, 1895–1995: The Japanese American Experience* (Berkeley: Berkeley Historical Society, 1995), 8–11.
2. Interview with Wilder Bentley, Berkeley, 1986.
3. Interview with Karl Kasten, Berkeley, April 10, 1986.
4. Yoshiko Uchida, *Desert Exile* (Seattle: University of Washington Press, 1982), 47.
5. Letter from Beth Blake to Chiura Obata, March 23, 1942.
6. Ruth W. Kingman, *The Fair Play Committee and Citizen Participation: An Interview by Rosemary Levenson,* in *Japanese American Relocation Reviewed, Vol-*

ume II: The Internment (Berkeley: Bancroft Library, U.C.B. Regional Oral History Project, 1973), 32. Quoted with permission.

7. Hal Johnston, "So We're Told; Novel Scholarship," *Berkeley Daily Gazette*, April 21, 1942.

8. Olivia Skinner, "Tranquil Artistry," *St. Louis Post Dispatch*, June 23, 1968.

9. Roger Montgomery, "A Conversation with Gyo Obata," *College of Environmental Design News*, Spring 1992.

10. Interview with Geraldine Knight Scott, Berkeley, April 1986.

TANFORAN

1. Letter from Monroe Deutsch, April 1942, in Kingman, *The Fair Play Committee and Citizen Participation*, 85–86. Quoted with permission.

2. Eleanor Breed, "War Comes to the Church Door" in Kingman, *The Fair Play Committee and Citizen Participation*, 87. Quoted with permission.

3. Letter from Dorothy Skelton to the author, June 20, 1986.

4. Kingman, *The Fair Play Committee and Citizen Participation*, 12. Quoted with permission.

5. Taylor, *Jewel of the Desert*, 64.

6. Letter from Chiura Obata to Bob Winston, 1942. From the Dorothy Geneva Simmons Skelton papers.

7. Barrack 61
Room 5
Tanforan, San Bruno
May 18, 1942
Dear Jerry:

Thank you for all your kindness during Evacuation time and also for assisting Gyo go to Washington University. We have received many letters from him saying how much he is enjoying his study there. I am glad that he was able to continue his study as I do not like to see him waste his time here in camp.

I have been very busy sketching Herb flowers which a friend from Berkeley brought to me and making sketches of camp life. Also I am extremely busy organizing an Art Department here. Within the past few days we have already had an enrollment of 231 students. We hope that we may be able to organize a good department here.

We are slowly beccomming [sic] adjusted to this new camp life. The weather here is cold & windy and at times becomes hot. Mrs. Obata is in bed today with a cold. Yuri was also sick last week. We have a single room for the seven of us of size 19' x 19'—Kim & Masa, Mr. & Mrs. Sato, Mrs. Obata, Yuri & I. We have very little privacy or space but I still manage to sketch & paint. Will write again, Sincerely, C. Obata

TANFORAN ART SCHOOL

1. *Survey of Obata Art Project*, 1942. From the Obata family collection.

2. *Obasan*: an older woman or grandmother.

3. The Tanforan Art School teaching staff were: Mine Okubo, Masao Yabuki, Tom Yamamoto, Miyo Ichiyasu, Matsusaburo Hibi, Byron Takashi Tsuzuki, Teruo Iyama, Kathryn Kawamorita, Mary Ogura, George Shimotori, Teruo Nagai, Bennie Nobori, Siberius Saito, Itsuko Yoshiwara, Kimio Obata, Shinji Yamamoto, and Chiura Obata as director. Additional staff were Mary Takahashi, Grace Iida, Shizuye Akiyoshi, James Yamakoshi and Albert Hirota.

4. *Survey of Obata Art Project*, 1942.

5. Ibid.

6. Deborah Gesensway and Mindy Roseman, *Beyond Words: Images from America's Concentration Camps* (Ithaca, New York: Cornell University Press, 1987), 71.

7. Ibid, 19.

8. Letter from Eleanor Breed to Chiura Obata, September 29, 1942.

9. *Survey of Obata Art Project*, 1942.

10. Ibid.

11. Refers to a Japanese saying, "*Neko no te mo kari-tai*": I'm so busy I could use the cat's hand.

12. Interview with Geraldine Knight Scott, Berkeley, April 1986. At the bequest of Scott, a Japanese gate was erected in the U.C. Botanical Garden in 1998 in honor of Chiura and Haruko Obata.

13. Letter from Geraldine Scott to Chiura Obata, 1942.

14. Letter from Haruko Obata to Mr. Clark, 1942.

15. *WRA Case Files: Chiura Obata*, 1942–1945. National Archives Building, Washington, D.C.

16. *Sensei*: honorific title of teacher.

17. Letter from Maeda to Chiura Obata, September 7, 1942.

18. Hibi Diary, 1942, Hisako Hibi family papers.

TOPAZ

1. Matsusaburo Hibi, *History and Development of the Topaz Art School*, version 1943.

2. Hibi Diary, 1942, Hisako Hibi family papers.

3. Letter from Chiura Obata to Eleanor Breed, November 14, 1942.

4. Dec. 15, '42
 Dear Mr. Obata:
 My friend, Ray Strong, gave me a package of art materials, asking me to send them to one of the Relocation Centers as his contribution to aid some Japanese artist who might be hindered in his work through lack of material. So I am mail-ing this package to you today, since I know that you will be able to give it to a student, or for use in the school, anyway that you see fit. Be of good cheer, you are not forgotten—and let us know if there is anything we could do to help.
 Sincerely your friend
 Dorothea Lange Taylor

5. Matsusaburo Hibi, *History and Development of the Topaz Art School*, version 1943.

6. Letter from Chiura Obata to Eleanor Breed, November 14, 1942.

7. Letter from Chiura Obata to Ray Boynton, November 6, 1942.

8. *Nagare no Tabi*: "Stream's Journey," explains Dr. Clifford Uyeda, "is a metaphor—to have abso-lutely no control over one's destiny, as on a raft in a rapidly flowing river. One is forced to travel wherever the river takes you."

9. Letter from H. L. Dungan to Chiura Obata, December 27, 1942.

10. Michi Weglyn, *Years of Infamy: The Untold Story of America's Concentration Camps* (New York: William Morrow, 1976), 120.

11. Letter from Chiura Obata to Jack Boylin, January 22, 1942.

12. Letter from Haruko Obata to Mrs. Galen Fisher, ca 1943.

13. Maurine Larsen Nelson diary, ca 1980, Nelson family papers, Delta, Utah.

14. Letter from Chiura Obata to Dr. Schenkofsky, February 11, 1943.

15. Letter from Chiura Obata to Jack Boylin, March 20, 1943.

16. "Art Reflects Life in Relocation Camps," *Asia and the Americas*, October 1943.

17. Ralph G. Martin and Richard Harrity, *Eleanor Roosevelt: Her Life in Pictures*, (New York: Duell, Sloan and Pearce, 1958), 189.

18. Masako Yamamoto founded the Koho School of Sumi-e in New York City.

19. Letter from Chiura Obata to Eleanor Breed, April 23, 1943.

RELOCATION

1. Letter from Kim Obata to Ruth Kingman, 1943.

2. Letter from Jack Boylin to Chiura Obata, June 12, 1943.

3. Letter from Helen A. Burton to Mr. and Mrs. Obata, May 2, 1943.

4. Robert Gordon Sproul, "The test of a free country," June 29, 1944, in Kingman, *The Fair Play Committee and Citizen Participation*, 94. Quoted with permission.

5. Letter from Chiura Obata to Monroe Deutsch, 1945.

6. Letter from Robert Gordon Sproul to Chiura Obata, January 19, 1945.

7. Letter from Galen Fisher to Chiura Obata, October 2, 1945.

RETURN HOME

1. Letter from H. L. Dungan to Chiura Obata, September 3, 1945.

2. From the Hisako Hibi family papers.

3. "U.C. Professor Lectures to Art Classes," *Pacific Weekly*, February 1, 1946.

4. Architect Gyo Obata designed the Japanese American National Museum in Los Angeles in 1999.

COLOR PLATES

1. Letter from Chiura Obata to Dorothea Lange, September 29, 1942, in Dorothea Lange papers relating to the Japanese American relocation (BANC MSS 97/145 c), The Bancroft Library, University of California, Berkeley. Quoted with permission.

2. *Ninth Annual Drawing and Print Exhibition Catalogue* (San Francisco: San Francisco Art Association, January 31–February 25, 1945), foreword.

3. Hisako Hibi Oral History, March 23, 1986, San Francisco, interview by Eric Saul. National Japanese American Historical Society Archives.

EPILOGUE

1. Due to the efforts of the Topaz Museum in Delta, Utah, the site of the Topaz internment camp is designated in the Save America's Treasures program. It is also in the National Register of Historic Places.

2. Elizabeth Kastor, "Remembrance of Sorrows Past; The Smithsonian's Hard Look at World War II Internment of Japanese Americans," *Washington Post*, October 1, 1987.

3. Issa, Ryōkan and Bashō are famous Japanese Edo period haiku poets.

CHAPTER HEADING QUOTATIONS

Page 1: Lecture by Chiura Obata, *Natural Rhythm and Harmony*, 1933.

Page 9: Letter from Chiura Obata to Allen Eaton, January 4, 1947.

Page 19: Exhibition text of Chiura Obata's internment art, ca 1946.

Page 35: Tanforan Camp Art School, 1942.

Page 53: Topaz Art School graduation speech by Chiura Obata, March 1943.

Page 97: Chiura Obata Oral History, 1965.

Page 105: Chiura Obata Oral History, 1965.

Page 137: "The Three Fundamental Strokes" in Chiura Obata, *Sumie* (Berkeley: self-published by the author, 1967), 19.

Bibliography

PRIMARY SOURCES

Most of the Chiura Obata quotations and correspondence in this book are from his papers in the Obata family collection or from his 1965 oral history conducted by Masuji Fujii in Berkeley. This interview was translated into English by Akiko Shibagaki and Kimi Hill. The original oral history is part of the Japanese American Research Project, Department of Special Collections, Young Research Library, UCLA. Quotations by Haruko Obata are largely from an oral history conducted by Kimi Hill from 1985 to 1986 in Berkeley and translated by Yuri Kodani. Any unattributed quotes from Chiura or Haruko come from these sources.

In 1986, Kimi Hill taped interviews with Wilder Bentley (Berkeley), Beth Blake (San Francisco, April 16), May Blos (Berkeley), Doris Heinz (Mill Valley), Karl Kasten (Berkeley, April 10), Ruth Kingman (Oakland, April 18), and Geraldine Knight Scott (Berkeley, April 1), and conducted untaped interviews with Shichinosuke Asano (San Francisco) and Hisako Hibi (San Francisco).

OTHER ARCHIVAL SOURCES

Hisako Hibi family papers. San Francisco, California.

Dorothy Geneva Simmons Skelton papers. 1941–1986, Brightwood, Virginia.

WRA Case Files: Chiura Obata. 1942–1945. National Archives Building, Washington, D.C.

SECONDARY SOURCES

Arrington, Leonard J. *The Price of Prejudice: The Japanese-American Relocation Center in Utah during World War II*. Delta, Utah: The Topaz Museum, 1997 reprint.

"Chiura Obata." In *California Art Research*, First series, 120–160. San Francisco: WPA Federal Art Project, 1937.

Eaton, Allen H. *Beauty Behind Barbed Wire: The Arts of the Japanese in Our War Relocation Camps*. New York: Harper & Brothers, 1952.

Gesensway, Deborah, and Mindy Roseman. *Beyond Words: Images from America's Concentration Camps*. Ithaca, New York: Cornell University Press, 1987.

Higa, Karen, et. al. *The View from Within: Japanese American Art from the Internment Camps, 1942–1945*. Exhibition catalog. Los Angeles: Japanese American National Museum, 1992.

Kingman, Ruth W. *The Fair Play Committee and Citizen Participation: An Interview by Rosemary Levenson*, in *Japanese-American Relocation Reviewed, Volume II: The Internment*. Berkeley: Bancroft Library, UCB Regional Oral History Office, 1973.

Kiyama, Henry (Yoshitaka). *The Four Immigrants Manga: A Japanese Experience in San Francisco, 1904–1924*. Translated by Frederik L. Schodt. Berkeley: Stone Bridge Press, 1999.

Obata's Yosemite: The Art and Letters of Chiura Obata from His Trip to the High Sierra in 1927. Yosemite National Park, California: Yosemite Association, 1993.

Okubo, Mine. *Citizen 13660*. Seattle: University of Washington Press, © 1946, 1983 reprint.

Personal Justice Denied: Report of the Commission on Wartime Relocation and Internment of Civilians. Seattle: University of Washington Press, © 1982, 1997 reprint.

Taylor, Sandra C. *Jewel of the Desert: Japanese American Internment at Topaz*. Berkeley: University of California Press, 1993.

Trek, 1942–1943. Reports Division, Central Utah Relocation Project.

Uchida, Yoshiko. *Desert Exile*. Seattle: University of Washington Press, 1982.

Weglyn, Michi. *Years of Infamy: The Untold Story of America's Concentration Camps*. New York: William Morrow, 1976.

Wilson, Robert A., and Bill Hosokawa. *East to America: A History of the Japanese in the United States*. New York: William Morrow, 1980.

Yamada, Robert T. *The Berkeley Legacy, 1895–1995: The Japanese American Experience*. Berkeley: Berkeley Historical Society, 1995.

Kimi Kodani Hill began researching the lives of her grandparents, Chiura and Haruko Obata, in 1985, eventually assuming the role of family historian. Since 1993, she has presented numerous slide lectures on her grandfather's life and work. She has also served as a consultant for an exhibit at the Smithsonian Institution on the Japanese American internment. A graduate of the University of California, Berkeley, and the California College of Arts and Crafts, Oakland, she currently lives in Berkeley.